CARDINAL NEWMAN

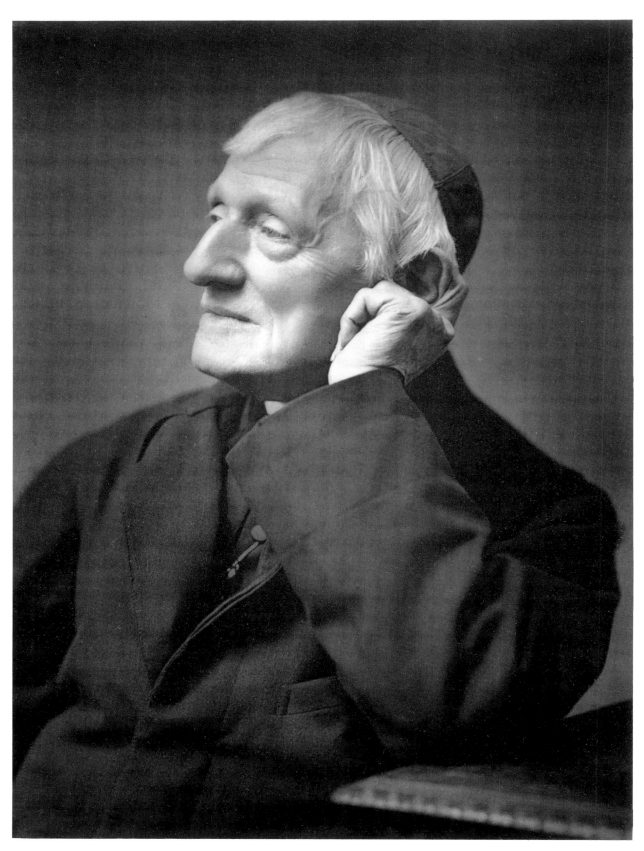

John Henry Newman by Herbert Rose Barraud (no. 157)

CARDINAL NEWMAN
1801-90

A Centenary Exhibition

Susan Foister

Introduction by Owen Chadwick

NATIONAL PORTRAIT GALLERY
PUBLICATIONS

Published for the exhibition held 2 March–20 May 1990

Exhibition organizer: Susan Foister

Exhibition designer: Caroline Brown

Published by National Portrait Gallery Publications,
National Portrait Gallery,
St Martin's Place, London WC2H 0HE, England, 1990

British Library Cataloguing in Publication Data
Foister, Susan
 Cardinal Newman 1801–90.
 1. England. Catholic Church. Newman, John Henry, 1801–
 1890. Items associated with Newman, John Henry, 1801–
 1890. Catalogues, indexes
 I. Title II. National Portrait Gallery, Great Britain 282.092

 ISBN 1–85514–023–3

Catalogue edited by Gillian Forrester

Designed by James Shurmer

Phototypeset by Southern Positives and Negatives (SPAN),
Lingfield, Surrey, England

Printed in England by Jolly & Barber Ltd, Rugby,
Warwickshire

Bound by W. H. Ware & Sons Limited

Photographic acknowledgements
The exhibition organizers would like to thank the following for
making copyright photographs available to illustrate the
following catalogue entries: The Greater London Photographic
Library 6; The Provost and Scholars of Oriel College, Oxford 17;
The Oxfordshire County Council, Department of Leisure and
Arts, Library Service, Local Studies 23(ii), 76(ii), 78; The Royal
Commission on the Historical Monuments of England 75(i). All
other photographs were provided by the lenders or the sources
given in the catalogue. All exhibits from the Birmingham and
London Oratories and for the following catalogue entries were
photographed by Frank Thurston: 1, 4, 11, 13, 22, 25, 40, 41, 44,
69, 128, 172.

The exhibition organisers would like to thank Oxford
University Press for permission to publish copyright material
from *John Henry Newman: A Biography* by Ian Ker.

Contents

Foreword and Acknowledgements

This exhibition continues the series of biographical exhibitions large and small at the National Portrait Gallery, which have included in recent years *Thomas More*, *Handel*, and *T. E. Lawrence*, as well as, among the Victorians, *Thomas Carlyle* and *General Gordon*, and commemorates the centenary of John Henry Newman's death which falls on 14 August 1990.

I am immensely grateful to the Fathers of the Birmingham Oratory for their tremendous generosity in lending so many items, without which the exhibition could not have taken its present form, and particularly to the Very Reverend Gregory Winterton for his great kindness on my visits to the Oratory, and for the patience with which he has borne the Gallery's disruptions to the life of the Oratory. I am also grateful to him for allowing me to make use of an unpublished paper on Newman's portraits by Father Henry Tristram. I must also acknowledge the help of the Oratory's immensely knowledgeable Archivist, Gerard Tracey.

I am also greatly indebted to the Reverend Professor Owen Chadwick, our Chairman of Trustees, who readily agreed to write the introduction to this catalogue, whose writings on Newman and on the Victorian Church I have drawn on heavily, and who has been a source of encouragement in the preparation of the exhibition. Among others who have been generous with their time are Clive Wainwright, who gave valuable advice on the Gothic Revival and kindly read some of my entries, Miss Glennys Wild and Mrs Hilda Wakefield at the City Museum and Art Gallery, Birmingham, who searched for references in the archives of Hardman & Co. for me, and Dr John Martin Robinson, Librarian to His Grace the Duke of Norfolk, who searched for references in the Arundel Castle muniments. I must also give particular thanks to those of Newman's descendants who have been generous with their time and possessions, Mr Phillip Fenn, Mr David Mozley and Miss Eleanor Miller. I am also extremely grateful to Watts & Co. for sponsoring the exhibition by providing wallpaper for the exhibition design.

I am very grateful to Her Majesty The Queen and others who have lent to the exhibition, and also to Philip Attwood, The Reverend Vincent Brady, Sister Brigitta, Oliver Davies, Sister Evelyn, Mark Jones, Antony Griffiths, Nicholas Kingsley, The Very Reverend Canon Oliver Kelly, Mrs Margaret Kirwin, Miss Janie Cottis, Lady Millar, Dr Jerrold Northrop Moore, Dr Tessa Murdoch, Father Michael Napier, Miss Jennifer Ramkalawon, Mrs Ian Rodger, The Reverend Dr Geoffrey Rowell, Mrs Henrietta Ryan, Stephen Wildman, Anne Woodward and Lucy Whitaker.

Finally, I must thank my colleagues at the National Portrait Gallery who have worked on this exhibition with their usual enthusiasm and efficiency: Kathleen Soriano, Claire Spence, Carole Patey, Sarah Kemp, David Saywell, John Adamson, Gillian Forrester, Caroline Brown, Kai Kin Yung, Tim Moreton, Jacob Simon, Jonathan Franklin, Terence Pepper, Ian Thomas, Valerie Vaughan Batson, Rosemary Evison, Suzanne Benney, Sally Crowden and, lastly, Penny Dearsley who has willingly given me every kind of assistance during the preparation of the exhibition.

SUSAN FOISTER

Introduction

John Henry Newman was the most interesting of all the English churchmen during the last century. He had a sensitive nature, a questing mind, and a poetic gift which on occasion (though not on all occasions) also enabled him to write poetically beautiful prose. He found himself at that moment of history when all Europe was reacting against the excesses of the French Revolution, and thought that it must rediscover its historic bases for society, whether in history or art or religion or morality. It was a conservative moment which expressed itself in the rediscovery of the past, as in novels by Sir Walter Scott or a keener historical interest in the Middle Ages or a revived Gothic in the new school of architecture. All his long life of eighty-nine years Newman thought of himself as a sort of conservative. He wanted to revive the old faith of England, to resist what he regarded as the corroding effects of modern rationalism on Christian teaching and therefore on the morals of society, to retain the highest ideal of education which he could find in the past, to value tradition instead of dismissing it as a dead hand on the development of modern society.

But if all this makes Newman sound like a man in the last ditch against the vast and beneficial innovations of the nineteenth century – and just at times, though rarely, he made himself sound like that – nothing could be more untrue. He was much more a reformer than he was a conservative. He put forward an historic ideal of university education, in a book which is still the classical book on the subject. But the university which he described had never existed, and never could or would quite exist. Newman was a reformer as Sir Thomas More was a reformer with his Utopia, putting forward an ideal of society or life which had a recognizable relation to the possibilities open to mankind but which could not actually exist in practice. Newman put forward an ideal of a Catholic Church with a powerful impact upon the morals and the thinking of humanity. The ideal was too high for the practice. He tried it on his own Church, the Church of England in which he was born and brought up and to which he felt he owed his conversion and his fundamental Christian principles. That Church, he felt after a campaign of nine years, and by his early forties, was not capable of reaching up after the ideal which he set before it. He turned to the Roman Catholic Church, of which he was a member for all the second half of his life. He thought thereafter that his second Church had a better chance than the first and never lost sight of the vision of Mount Sion. But never after the first flush of enthusiasm was he tempted to think that his new Church had arrived anywhere near the ideal which he sought.

Therefore this conservative, as he seemed at first sight to be, was an innovator struggling to change the habits and ideas of the community of which he was a member, and discovering like any reformer that a lot of the other members resented being invited to change their habits or ideas. Wherever he went he gathered disciples and enemies, but, like reformers generally, more of the second than the first.

Yet in both the Church of England and in the Roman Catholic Church he was influential in the longer run. His legacy to the one was different from his legacy to the other. The Church of England received an abiding impetus to deepen its ways of prayer, and the dignity of its worship, and the expression of its idea of holiness. He tried to raise it up from

a certain dullness or complacency or woolliness to an understanding of the necessity of a creed within faith. In the Roman Catholic Church he stood for an intellectual integrity and freedom of mind. In those days the Church of Rome (mainly for political reasons in Italy) acquired a last ditch mentality which was hard for ordinary Catholics to resist. Newman had the convictions, and the courage, and intelligence to be able to stand for freedom of the mind while he was loyal to the Pope. In the age when Charles Darwin wrote about evolution, and the historians examined the nature of legend in the stories of the Old Testament, it was very important for a Catholic to say that historical study had its rights, and scientific enquiry had its freedoms, and a Catholic conscience had its duty even against a Pope. This was why Catholic reformers of the middle twentieth century came to look upon him as a prophet born out of his time.

He wrote two books, and certain verses, which proved to have an enduring importance. His work on the Idea of a University is still the noblest statement of the older ideal that even in an age of technology has still some validity. Then he was accused by the novelist Kingsley of not caring about truth, and answered the libel with a defence of his own career thus far, the *Apologia Pro Vita Sua*. This book persuaded Britain of his honesty, and so diminished an historic British suspicion of Roman Catholics which went back to the Spanish Armada or before. It brought the two Churches nearer in the possibility of friendship and mutual respect. These books, the *Idea of a University* and the *Apologia*, are the two books which continue to be read by people outside the narrower realm of professional students of the Victorian Age.

Finally, his writing of verse carried his influence far beyond both his Churches. At the time of the *Apologia* he was thinking how old he grew and began to meditate on death, and the result was *The Dream of Gerontius*, which is a poetic description of the thoughts and prayers of a dying man and of a judgement immediately after death. It did not become famous until ten years after Newman's death when Edward Elgar, who was personally moved by its depth of feeling, set it to some great music. But it also contained verses which were valued in every Church in the world, especially the hymn, 'Praise to the Holiest in the Height'.

Yet the poem which most captured the affections of English-speaking peoples was written long before, in his Anglican days, while he was on his way back from a holiday in Italy and Sicily and was becalmed off Sardinia: 'Lead, Kindly Light'. Later in life he did not quite like it that this poem had become so valued as a hymn, for it made faith sound hesitant and moving among shadows and he preferred words that were more confident. But since in the age of Darwin and all the new discoveries the Victorians felt their faith to pass among shadows, it was 'Lead, Kindly Light', with which they fell in love.

Personally, he was quiet and unpretentious; a musician who in earlier life took his recreation by playing the violin; rather shy, so that even close friends sometimes found conversation awkward; by contrast a person who wrote many letters and they are never dull; liable to fits of melancholy and introspective moods, but mostly serene in temper and cheerfulness and at times with a delightful humour; so sensitive that he was difficult for his superiors to cope with but he was fated to have superiors incapable of understanding him; a friend with strong affections for a few intimates, a prayerful man who loved sacraments, but even here was wholly unpretentious in his manner of devotion.

OWEN CHADWICK

A Chronology of Newman's Life

1801	Born 21 February in City of London
1808–16	Attended Ealing School
1817–20	Undergraduate at Trinity College, Oxford
1822	Fellow of Oriel College
1824	Ordained deacon
1826	College tutor
1828	Vicar of University Church of St Mary the Virgin, Oxford, and parish of Littlemore
1833	*Arians of the 4th Century* published. Newman travelled to Italy and the Mediterranean, where he wrote 'Lead Kindly Light'; on his return publication of *Tracts for the Times* began, the start of Oxford Movement
1841	*Tamworth Reading Room* published; *Tract XC* published to great controversy
1842	Moved out of Oxford to Littlemore
1843	Resigned as Vicar of St Mary's
1845	*Essay on the Development of Christian Doctrine* written; received into the Roman Catholic Church, 9 October
1847	Ordained priest at Rome
1848	*Loss and Gain*, a novel, published anonymously; the English Oratory founded at Old Oscott (Maryvale)
1849	Oratory moved to Alcester Street, Birmingham
1850	*Lectures on Certain Difficulties* given
1851	Newman found guilty of libel in the Achilli case
1852	Oratory moved to Edgbaston; Newman in Dublin founded the Catholic University; the *Idea of a University*, based on his lectures, issued in parts
1854–8	Rector of the Catholic University, Dublin
1859	The Oratory School, Birmingham, opened
1864	*Apologia Pro Vita Sua* published in parts
1865	*Dream of Gerontius* published
1875	*A Letter Addressed to his Grace the Duke of Norfolk* published
1879	Elevated to Cardinal by Pope Leo XIII in Rome 12 May
1890	Died 11 August

Notes and Abbreviations

Sizes of exhibits are given (height before width) in centimetres with the size in inches shown in parentheses.

The following works are referred to in abbreviated form throughout the catalogue:

Apologia:
> J. H. Newman, *Apologia Pro Vita Sua*, second edition of 1865, in *Newman: Prose and Poetry*, selected by Geoffrey Tillotson, London, 1957, pp. 507–789.

Belcher:
> Margaret Belcher, *A. W. N. Pugin: An Annotated Critical Bibliography*, London, 1987.

Bloxham papers:
> Scrapbooks of MSS and other material relating to J. H. Newman compiled by J. R. Bloxham (Magdalen College, Oxford).

Chadwick:
> Owen Chadwick, *The Victorian Church*, Part One 1829–1859, 3rd edition, 1971; Part Two 1860–1901, 2nd edition, 1972.

Colvin:
> Howard Colvin, *A Biographical Dictionary of British Architects 1600–1840*, London, 1978

Ker:
> Ian Ker, *John Henry Newman: A Biography*, Oxford, 1988.

Lane Poole:
> Mrs R. L. Lane Poole, *Portraits in Oxford Colleges*, 3 vols., Oxford, 1912–28.

Martin:
> Brian Martin, *John Henry Newman: His Life & Work*, London, 1982.

Mozley:
> Thomas Mozley, *Reminiscences chiefly of Oriel College and the Oxford Movement*, 2 vols., 1882.

Ormond:
> Richard Ormond, *Early Victorian Portraits*, 2 vols., London, 1971.

Patrick:
> James Patrick, 'Newman, Pugin and Gothic', *Victorian Studies* 24 (2), 1981, pp. 185–208.

Sugg:
> Joyce Sugg (ed.), *A Packet of Letters: A Selection from the Correspondence of John Henry Newman*, Oxford, 1983.

Trevor:
> Meriol Trevor, *A Light in Winter*, London, 1962.

Tristram:
> Henry Tristram, *Newman and his Portraits*, unpublished typescript (Birmingham Oratory).

Victorian Church Art:
> *Victorian Church Art*, exhibition catalogue, Victoria & Albert Museum, London, 1978.

Walker:
> Richard Walker, *Regency Portraits*, 2 vols., London, 1985.

I Young Newman 1801–33

John Henry Newman was born on 21 February 1800 in London, the eldest of six children. His father was a banker whose business collapsed in 1816. His mother's family was of Huguenot origin and Newman was brought up as a Calvinist, but in the *Apologia* he declared, 'I had no formal religious convictions until I was fifteen'. He attended Ealing School from 1806 to 1816, and then went up to Trinity College, Oxford, where he was awarded his degree, though he did not achieve the expected brilliant result. Nevertheless, in 1822 he was elected a Fellow of Oriel College, then considered the most academically outstanding college.

In 1824 he was ordained deacon and in 1826 was appointed College tutor at Oriel. There he had his first brush with controversy when he proposed that the College should recognize the individual responsibility of a tutor for his own students. He came to notice again in 1828 when he was appointed Vicar of St Mary the Virgin, Oxford, the University Church, where his preaching attracted large audiences (see nos. 54, 55, 56), and incumbent of the rural church of Littlemore.

Although his upbringing had placed him on the Evangelical side of the Church, which stressed Bible-reading as the foundation for religious belief, Newman's religious viewpoint was changing. He began to argue for the importance of the doctrines and tradition of the Church of England as handed down from the foundation of the Early Christian Church. Newman felt the Catholic Emancipation Act, passed in 1829, which allowed Catholics to become MPs, would seriously undermine the Anglican Church and was deeply concerned by the prospect of further legislation affecting the Church.

In 1833 he set off for the Mediterranean, visiting Rome on his way to Sicily, where he fell dangerously ill. One of his best known poems, 'Lead Kindly Light' (no. 26) was composed when becalmed on a boat off Sardinia.

1 The Fourdrinier Family
John Downman, c.1786

Oil on metal, 44.8 × 60.6 ($17\frac{5}{8}$ × $23\frac{7}{8}$)

PROVENANCE: By descent.

LITERATURE: *The Quiet Conquest*, exhibition catalogue, Museum of London, 1985, p. 180, no. 259, with bibliography.

Newman's mother, Jemima Fourdrinier (1772–1836), was of Huguenot descent. Her father, Henry Fourdrinier (1730–99), shown seated in the centre of no. 1, with Jemima standing next to him, was a paper manufacturer and wholesale stationer. His sons Henry (1766–1854; far left), and

Sealy (1774–1847; seated in front to the right), in 1807 patented a machine for making continuous paper, an invention of some importance (two machines were supplied to Tzar Alexander in 1814), but the brothers were bankrupted by the expense of protecting their patent.

In the background of the picture, behind Jemima Fourdrinier, is a memorial to her mother, also Jemima, who died in 1781. The other figures are: Jemima's other brothers Charles (1767–1841; far left) and John Rawson (1770–1836; seated to the left), on Henry Fourdrinier's left his sister Mary (b.1778) and on the far right his step-daughter Minerva Manning (b.1763). Jemima Fourdrinier married John Newman (d.1824) on 29 October 1799 at Lambeth Church.

The picture is unsigned, but convincingly ascribed to Downman; it appears to date from about 1786.

Illustrated in colour on p. 33.

Owned by Mr Philip Anthony Fourdrinier Fenn

2 Memorial ring commemorating Henry Fourdrinier

Gold and black enamel, diameter 2 ($\frac{7}{8}$)

Inscribed: HENRY FOURDRINIER ESQ OBT JAN 1799. AE 69

PROVENANCE: By descent.

A ring commemorating the death of Newman's maternal grandfather (see no. 1); the classical urn on the bezel echoes the urn in the background of no. 1.

David Mozley Esq.

3 Memorial ring commemorating John Newman

Gold and black enamel, diameter 2 ($\frac{7}{8}$)

Inscribed: JOHN NEWMAN OB. 1 JULY 1799. AE 65 JOHN. NEWMAN

PROVENANCE: By descent.

A ring commemorating the death of Newman's paternal grandfather: a slightly simpler ring than no. 2, as befitted the Newman family's less wealthy background.

David Mozley Esq.

4 Portrait believed to represent John Newman Senior (died 1824)
Unknown artist

Miniature, 6.2 × 5 ($2\frac{1}{2}$ × $1\frac{15}{16}$)

PROVENANCE: By descent.

The subject of the miniature is identified by family tradition as Newman's father. The only other portrait thought to be of

him, also a miniature, in a jewelled setting (reproduced Martin, p. 10) was destroyed (information courtesy of Miss E. Miller), and was also identified by family tradition. No. 4 appears to date from about 1800 or earlier and shows a much younger man, whose features are not incompatible with those of the sitter in the other miniature, which dates from a few years later. No. 4 might, then, show Newman's father around the time of his marriage in 1799.

David Mozley Esq.

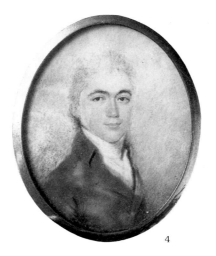

4

5 The Newman Family christening gown and bonnet

Embroidered and tucked white cotton gown and linen bonnet
PROVENANCE: By descent.

One of two gowns and bonnets which have descended in the Newman family, the style of this gown is that of the very early nineteenth century. It is conceivable therefore that this was the gown worn by Newman at his christening on 9 April 1801 at St Benet Fink in the City of London.

David Mozley Esq.

6 Grey Court House, Ham

Modern photograph, 1981

Newman later described the country house where he had spent the first few years of his life as 'Paradise'. He remembered looking 'at the windows of the room where I lay abed with candles in the windows in illumination for the victory at Trafalgar'. In September 1807, when Newman was six, the house was sold. Newman revisited the house, which had become a school by 1836, on more than one occasion in later life.

6

7 17 Southampton Street, London

Copyprint after a photograph at the Birmingham Oratory

Newman was born at 80 Old Broad Street in the City. His parents moved to Southampton Street (now Southampton Place) in Bloomsbury in 1803, and lived there and at Ham until the latter house was sold in 1807. When Newman's father's bank closed in 1816 and the family was plunged into a period of financial crisis, the house was let.

8 Newman's First Prayer Book

Book, 11×7 ($4\frac{1}{2} \times 2\frac{3}{4}$)
PROVENANCE: By descent.

The story of Newman's acquisition of this prayer book in 1815 is told in an inscription signed with Newman's initials and the date 23 September 1850: 'My mother promised to/ give me a Prayer Book – I was impatient she did not do so/at once – and without leave in/an impatient headstrong mood/ went and bought this for her – which/she, though she must have felt/it, without saying a word gave/me'.

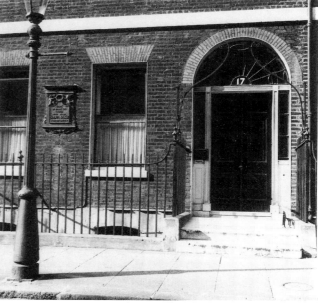

7

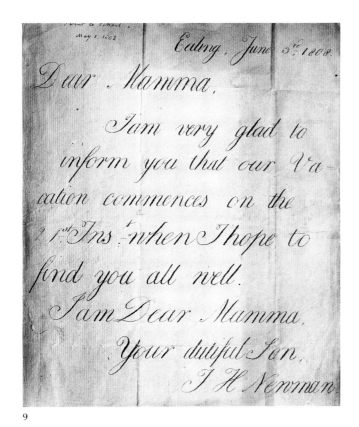

9

praise of God is headed by the words 'Verse Book' separated by a sketch of a cross and what appears to be a cross suspended from some beads as in a rosary. Newman referred to this apparently prophetic drawing in the *Apologia* (pp. 580–1), and described how looking again at the verse book as an adult, 'there was a device which almost took my breath away with surprise'. Newman concluded that he probably had been inspired by a description by one of the romantic novelists of the day 'but the strange thing is how, among the thousand objects which meet a boy's eyes, these in particular should so have fixed themselves in my mind, that I made them practically my own'.

The Fathers of the Birmingham Oratory

10 The Spy Society

'Daniel', 1815

Pencil, ink and watercolour on paper, 18.7 × 17.2 ($7\frac{3}{8}$ × $6\frac{3}{4}$)

Entitled 'Monitorial Spies', this caricature, inserted in *Juvenilia*, includes on the far right the earliest known portrait of Newman, aged about fourteen according to the date, 1815, written at the top right. The drawing appears to show eight pupils of Ealing School who had grouped themselves into a secret society, and who are identified in the 'References to the Plate below'. Here Newman appears as 'Mr Sophocles', and is portrayed as the group's leader (caricatured in the same profile view that Oxford caricaturists were to use much later, see nos. 54, 55, 56). Newman annotated the drawing with the identities of three of the group, including himself, and explained 'This caricature is the drawing of our enemy, Daniel'; the identity of 'Daniel' is unknown.

The Fathers of the Birmingham Oratory

The prayer book, an edition of 1811 in a red leather binding, was acquired over a year before Newman first felt the religious convictions to which he testified in the *Apologia*.

The book is inscribed on the flyleaf: 'John Newman/Janry 30th 1815'. Another note refers to Newman's mother's death in 1836.

David Mozley Esq.

9 Newman's 'Juvenilia'

(i) Autograph letter to his mother, 3 June 1808, 23.2 × 23 ($9\frac{1}{8}$ × $9\frac{1}{16}$)

(ii) Photograph of diary entries for 1810–11

(iii) Photograph of verse book, 11 February 1811

Newman's *Juvenilia* occupy a small bound volume, still kept in his room at the Birmingham Oratory; they include the drawing of the 'Spy Society' (no. 10), as well as various letters from Newman at school to his family and some early schoolboy diaries.

No. 9(i) is a letter written by the seven-year-old Newman during his first term at Ealing School; the adult Newman annotated the letter with the date when he started school, in May 1808. The *Juvenilia* volume includes several similar letters.

No. 9(ii) is part of a diary kept by Newman between 1810 and 1811, aged nine and ten: entries are brief and to the point: 'May 25 [1810] got into Ovid and Greek [May] 29 Oak Apple day [May] 30 fell in ditch'.

No. 9(iii): this page of English and Latin translations in

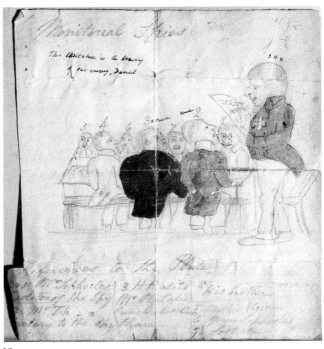

10

11 Harriett(?) 1803–52 and Mary 1809–1828 Newman

Maria Giberne, c.1827

Black and red chalks on paper, 12.7 × 21 (5 × 8¼)

PROVENANCE: By descent.

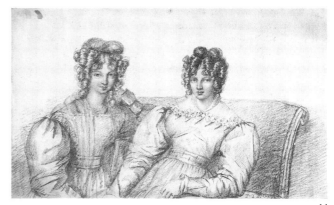

11

The sitters are identified in an inscription on the verso as Mary, Newman's youngest sister, on the right, and perhaps Harriett, the oldest sister, on the left. The signature in monogram of Maria Giberne appears on the drawing itself, and the date of Mary's death on 5 January 1828 means the drawing must predate the group portrait of the family (no. 13); it appears to be Maria Giberne's earliest extant drawing of members of the Newman family.

Maria Rosina Giberne (1802–85), described by Thomas Mozley as 'an early and ardent admirer of Newman' became a family friend. From a Huguenot family herself, her sister married Walter Mayers, who had been Newman's schoolmaster at Ealing. Newman's brother Francis proposed marriage to her, but she refused him. She corresponded frequently with Newman, and like him turned away from Evangelism towards the High Church, and followed him into the Catholic church in 1845 (see no. 84). All her works from this period are drawings (see also no. 22), but she later turned to oil painting (nos. 81, 83, 100).

Harriett Newman married Thomas Mozley, John Henry Newman's friend and biographer (see no. 22). Mary's early and sudden death was a great loss to Newman. 'She lived in an ideal world of happiness, the very sight of which made others happy'. (Ker, p. 30).

The Misses M. and E. Miller

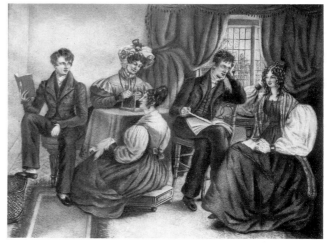

13

12 Mary Newman's Prayer Book

Book, 10.5 × 7 (4¼ × 2¾)

PROVENANCE: By descent.

This 1815 edition of the Prayer Book belonged to Mary Newman (see no. 11) and passed to Newman on her premature death. Newman inscribed on the flyleaf: 'Mary Sophia Newman/born Nov 9 1809/died suddenly Jan 5 1828/ ah! my Sister!/JHN'.

David Mozley Esq.

13 The Newman Family

Photograph, (?) retouched with black chalk, after a drawing by Maria Giberne, 27.9 × 35.6 (11 × 14)

PROVENANCE. By descent.

LITERATURE: Mozley I, p. 28; 'Cardinal Newman and the Studios', *Art Journal*, 1890, pp. 315–6, ill. p. 316.

Thomas Mozley, Newman's friend, and later brother-in-law (see no. 22) described how in the winter of 1829 the Newman family were offered a cottage at Nuneham Courteney by a Fellow of Oriel: 'A special interest attached to this cottage from its being the scene of a remarkable family group, including the whole surviving Newman family in chalk, by Miss Maria R. Giberne'. (Mozley, I, p. 28).

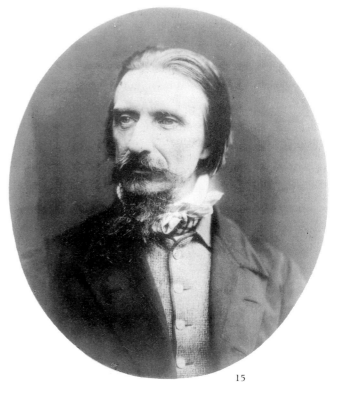

15

The whereabouts of Maria Giberne's original drawing is unknown: no. 13 is a retouched photograph. The sitters are identified in an inscription on the back of the frame: (left to right) Francis (see no. 15), Mrs Newman (see no. 76(ii)), Harriett (see no. 11), John Henry and Jemima (1807–89). In a letter (Bloxam papers I, p. 28; 27 October 1885) Mrs Anne Mozley identified the female sitters as Jemima on the left and Harriett on the right, contradicting the inscription, and added 'MRG was never successful in *mouths*'. The group does not include Newman's youngest sister Mary, who died in 1828 (see no. 11), or his brother Charles (1802–96).

The Misses M. and E. Miller

14 John Henry Newman, 'Memorials of the Past' Oxford, 1832

Book, 18.7 × 10.8 (7¼ × 4¾)

PROVENANCE: By descent.

This copy of a book of verse from Newman's youth is inscribed on the flyleaf: 'I give away my first copy/to my dear Aunt Newman/JHN/Jan 30. 1832'. The poems collected here date from 1818 to 1831 and include a number of poems to Newman's brothers and sisters of the sort which it was common to inscribe in the keepsake albums of the day.

David Mozley Esq.

15 Francis William Newman 1805–97

Copyprint after a photograph by Herbert Watkins (1858)

The youngest son of the Newman family, he was educated at Ealing School, like his brothers, and then in 1821 went up to Oxford. By this time, his father's bank had collapsed and he was dependent on his eldest brothers for financial support; he first lodged with them, then with Joseph Blanco White (see no. 20). On taking up residence at Worcester College in 1824 he found that his brother John had hung an engraving of the Virgin after Correggio in his rooms; shocked by the implicit Roman Catholicism, he immediately removed it. He took a brilliant degree and subsequently pursued an academic career, becoming Professor of Latin at University College London in 1846. He had by this time abandoned the Anglican church and become a Nonconformist, much to the horror of John who wrote to him in 1835 deploring the 'low arrogant cruel ultra-Protestant principle' according to which 'everyone may gain the true doctrine of the gospel for himself from the Bible'. (Ker, p. 123). In 1877 John Henry Newman wrote of Francis: 'Much as we love each other, neither would like to be mistaken for each other'.

National Portrait Gallery Archive

16 Oriel College, Oxford

Copyprint after a photograph at the Birmingham Oratory

Newman was elected a Fellow of Oriel on 12 April 1822. The news of his success was brought to him as he was playing his violin, and he was told that his presence was required

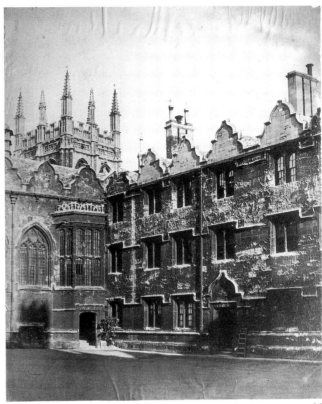

16

immediately. Newman later told how he merely answered, 'Very well', but 'no sooner had the man left, than he flung down his instrument, and dashed down stairs with all speed to Oriel College'. (Ker, p. 17)

In the photograph Newman's rooms in college are to the right of the oriel window on the first floor; Hurrell Froude's rooms were above (see no. 57). Newman's rooms were originally occupied by Whateley (see no. 19) and when he took them over he apparently found Whateley's herrings still hanging up on a string from the window (Bloxam papers I, p. 94)

17 Edward Hawkins 1789–1882

Copyprint after an oil painting by Sir Francis Grant at Oriel College, Oxford

'I can say with a full heart that I love him, and have never ceased to love', wrote Newman, 'though he provoked me very much from time to time'. (*Apologia*, p. 584) Edward Hawkins succeeded Edward Copleston (see no. 18) as Provost of Oriel in 1828; Newman and Pusey supported him rather than the other candidate, John Keble, for, as Newman remarked, 'we are not electing an Angel, but a Provost'. Hawkins had been appointed Vicar of St Mary's in 1823; when he resigned on becoming Provost, Newman succeeded him.

In the *Apologia* Newman paid tribute to the influence on him of Hawkins's sermon on Tradition preached in 1818 and published the following year, in which Hawkins argued that

doctrine should be sought in the catechism and creeds, rather than the Bible. This was a significant step in Newman's movement away from a Bible-based, low church Protestantism. In 1831, however, Newman clashed with Hawkins when the Provost refused to agree to Newman's proposal for a different system of tutorship (see Introduction to Section I). Richard Hurrell Froude (see no. 57) and Robert Wilberforce (see no. 108) agreed with Newman. Later, Hawkins was a vigorous opponent of the Tractarians; he continued as Provost until the age of eighty-five.

18 Edward Copleston 1795–1849

John Downman, 1810

Watercolour over pencil on paper, 30.3 × 24.2 (11$\frac{15}{16}$ × 9$\frac{1}{2}$)
PROVENANCE: Oswald Magniac; purchased, 1951.

Copleston was Provost of Oriel College, Oxford when Newman was made a Fellow in 1822. Newman described the 'kind courteousness which sat so well on him' in the *Apologia* (p. 590). He had been made Provost in 1814 after being Dean for some years, and much of the high standing which Oriel had in the University can be attributed to his influence. He remained Provost until his appointment as Dean of Chester in 1826; subsequently, in 1827, he was made Bishop of Llandaff and Dean of St Paul's. A classicist, he became Professor of Poetry at Oxford in 1802, but was also keenly interested in political and economic affairs.

The Visitors of the Ashmolean Museum, Oxford

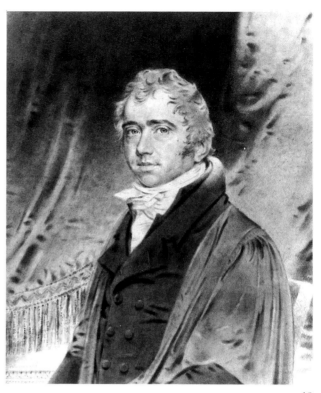

18

19 Richard Whateley 1787–1863

H. Meyer after a portrait by C. Grey

Stipple engraving, 23 × 15.2 (9 × 6)

Richard Whateley was elected Fellow of Oriel in 1811; an unconventional man, he was known at Oxford as the White Bear and could be seen early in the morning walking cross-country, wearing a white hat and rough white coat, or in the evenings showing off the tricks of his spaniel dog Sailor, who would climb a tree and drop into the river. He attracted the attention of journalists, who in 1830 branded Whateley, Arnold, Hawkins and their colleagues at Oriel the 'Noetics', or 'Thinkers'.

Whateley was an eminent logician, and Newman later wrote that, 'He, emphatically, opened my mind and taught me to think and to use my reason'. In 1825 Whateley was appointed Principal of Alban Hall, Oxford, which enjoyed an extremely low academic reputation; with Newman as his first Vice-Principal (until 1826) he set out to improve it. To Whateley, an advocate of the independence of Church and State, Newman attributed the growth of his own view that the State should cease to interfere with the Church, but the two men began to diverge in their views as Newman moved away from liberalism. The breach widened when in 1829 Newman voted against Robert Peel's re-election as the University MP. Whateley's response was to invite the abstinent, shy Newman to a party of port-swilling dons.

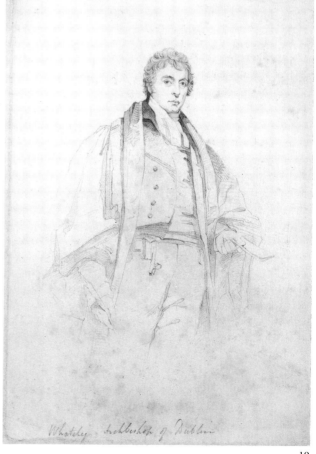

19

Whateley was appointed Archbishop of Dublin in 1831 where he presided over major and highly unpopular changes in the Irish Church, and the introduction in schools of a course of religious instruction theoretically acceptable to both Catholics and Protestants.

National Portrait Gallery Archive

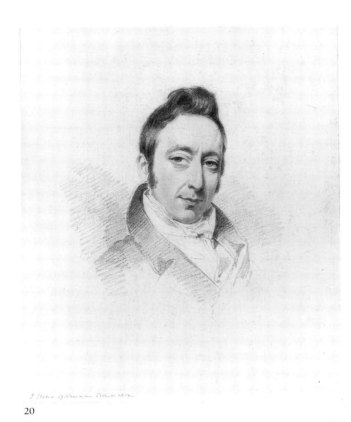

20 Joseph Blanco White 1775–1841

(?Joseph) Slater, 1812

Pencil and wash on paper, 19.7 × 15.4 ($7\frac{3}{4}$ × $6\frac{1}{4}$)

PROVENANCE: Given by Roland Heath of Bletchley, 1951.

LITERATURE: Walker I, p.552.

Born into a family of Irish Catholic merchants who had settled in Spain two generations earlier and translated their name to 'Blanco', Joseph Blanco White became a Catholic priest but later lost his faith. He escaped to England in 1810 during the Napoleonic Wars, added 'White' to his name, and became a political writer. On regaining his religious faith he became an Anglican clergyman in 1814 as well as a prolific political writer. In 1826 White was made an MA by Oxford University and became a member of the Oriel common-room, where he played the violin with Newman and became a particular friend of Whateley (see no. 19). In 1828 he was appointed editor of the *London Review*, to which Newman contributed an essay on 'Poetry with reference to Aristotle's Poetics'. Blanco White moved to Dublin when Whateley became Archbishop there, but his views became increasingly liberal and rational, and in 1835 he settled in Liverpool as a Unitarian, much to Newman's distress – he regarded this 'defection' as an example of the 'flood of scepticism' faced by the Church (Ker, p.119); from then on, 'he [Blanco White] made himself dead to me' (*Apologia*, p.587). In his autobiography White wrote that Newman's 'sudden union with the most violent bigots was inexplicable to me'. (Quoted in *Apologia*, pp.613–4)

Slater's drawing was executed two years after Joseph Blanco White's arrival in England.

National Portrait Gallery (NPG 3788)

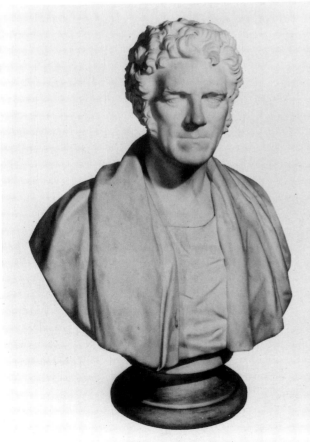

21 Thomas Arnold 1795–1842

William Behnes, incised and dated 1849

Marble bust, 76.2 (30) h.

PROVENANCE: James Lee, Bishop of Manchester, presented by him, 1864.

LITERATURE: Ormond I, p.17.

Thomas Arnold, perhaps best known as the reforming head-master of Rugby School (1828–41) was between 1815 and 1828 one of the group of outstanding academics including Keble (see no.48), Copleston (see no.18), Whateley (see no. 19), Hawkins (see no.17) and Hampden (see no.59) who held Fellowships at Oriel College and contributed to its brilliant reputation in the early nineteenth century.

In 1833, when controversy over the status of the Church of England was at its height, Arnold published his pamphlet,

The Principles of Church Reform, in which he advocated the admission of all dissenters to the Church of England. A vigorous opponent of the Oxford Movement, he regarded the Tractarians as a greater danger to the Church than Roman Catholicism, and was a supporter of Hampden's professorship (see no. 59), which Newman opposed.

Arnold returned to Oxford in 1841, when he was appointed Regius Professor of History. Newman, while deploring Arnold's views, which were diametrically opposed to his own, was an admirer of his work at Rugby, and, on his death in 1842, commended him 'as having done a work, when they [i.e., Whateley, Hawkins etc.] are merely talkers'. (Ker, pp. 251–2)

William Behnes's bust was executed posthumously.

National Portrait Gallery (NPG 168)

22 Thomas Mozley 1806–93
Maria Giberne, signed and dated 1832

Pencil and coloured chalks, 14.3 × 10.5 (5½ × 4⅛)
PROVENANCE: by descent.

Thomas Mozley was originally a pupil of Newman's at Oriel, where he obtained his degree in 1828; he was ordained in 1832 and became junior treasurer of Oriel in 1835. In 1836 he married Newman's sister Harriett (see nos. 11, 13). Mozley

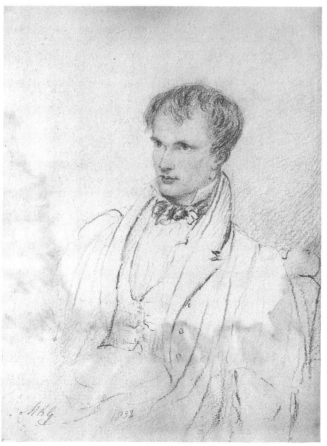

22

was an enthusiastic supporter of the Tractarian movement, and succeeded Newman as editor of the *British Critic* in 1841; he later wrote leaders for *The Times*. He considered becoming a Roman Catholic in 1843; Newman tried to dissuade him and Mozley remained an Anglican; this led to an estrangement between Newman and his sister. His *Reminiscences, chiefly of Oriel and the Oxford Movement* (2 vols, 1882) were badly received by Newman, mainly because of references to his family which he considered inaccurate.

The drawing is inscribed on the back: 'The Rev^nd Thomas Mozley/Perpetual Curate of Morton Pinkney/drawn by/ Maria Giberne/Rose Hill Oxford/July 14th 1832/presented to Ann Mozley by the artist'. Rose Hill was the Newman family house at this period. Maria Giberne also depicted Mozley with Newman and Richard Hurrell Froude in the same year, in a drawing of which only a photograph now survives at Oriel College. (Lane Poole, II, p. 101)

David Mozley Esq.

23 The Church of St Mary the Virgin, Oxford

(i) Exterior: Photograph after an engraving of 1814
(ii) Interior, looking towards the West End: Photograph after a drawing by McKenzie of 1834

Newman was appointed Vicar of the University Church of St Mary the Virgin in 1828, where he frequently lectured and preached (see no. 53) until relinquishing his appointment in 1841. The church meant a great deal to him, and he wrote in the *Apologia* that becoming Vicar 'was to me like the feeling of spring weather after winter: and if I may so speak, I came out of my shell; I remained out of it till 1841'. (p. 590) Newman kept a photograph of St Mary's in his room at the Birmingham Oratory, where it still hangs today.

24 John Henry Newman, 'The Arians of the Fourth Century' London, 1833

Book, 23.5 × 16.5 (9¼ × 6½)
PROVENANCE: Newman; The Oratory, Birmingham.

Newman's first book was written as a result of an invitation from the clergyman Hugh Rose in 1831 to write a history of the Early Church Councils to be published in the Theological Library series edited by Rose and Archdeacon Lyall. He finished writing the text in the summer of 1832, but it was rejected by Lyall for the projected series since Newman, as he himself admitted, had not written about the Councils, as agreed, but about the background to the Council of Nicaea, the Arian heresy, in which the existence of the Trinity was denied. As Newman described in the *Apologia*, 'of its 422 pages . . . the Council of Nicaea did not appear till the 254th, and then occupied at most twenty pages'. It was agreed that the book merited publication as a separate study in its own right, although Newman later thought *The Arians of the Fourth Century* 'the most imperfect work that was ever composed'.

In the *Apologia* he wrote, 'I do not know when I first learnt to consider that Antiquity was the true exponent of

the doctrines of Christianity and the basis of the Church of England', and his study of Arianism and the early Church confirmed his growing belief in the significance of the way doctrines had been handed down from the early Christian Church: only heretics like the Arians went counter to tradition and relied on private study of the holy scriptures to try to evolve a system of belief, as did the bible-reading evangelical Protestants, from whom Newman had drawn away.

The Fathers of the Birmingham Oratory

25 Nicholas Wiseman 1802–65

(?) Ferdinando Cavalleri, 1828

Oil on canvas, 20.7 × 17.2 (8⅛ × 6¾)

Wiseman, like Joseph Blanco White (no. 20) was born into an Irish Catholic merchant family settled in Spain; on the death of his father in 1804 the family returned to Ireland. Wiseman subsequently studied for the priesthood at the English College at Rome, and was ordained in 1825. He became Rector of the College in 1828 and Pope Leo XII appointed him Special English Preacher at Rome. In 1833 Newman and Richard Hurrell Froude (see no. 57) went twice to consult Wiseman on the possibility of reunion between the Churches of England and Rome; they discovered the prospects for such a reunion were unpropitious – 'it is a dream' recorded Newman. (Ker, p. 69)

The artist is presumably identical with Ferdinando Cavalleri, a popular artist among the English living or staying in Rome. An old letter inserted in the back of the frame states the portrait was 'painted by Cavalleri as a study for a large picture for the Marquis de Stacpoole', presumably the Earl of Limerick, Baron Foxford of Stackpole Court.

The Archbishop of Westminster

26 John Henry Newman, 'The Pillar of the Cloud' ('Lead Kindly Light')

Autograph manuscript

'Lead Kindly Light', or to give it Newman's title, 'The Pillar of the Cloud', was written, as the manuscript states, 'at sea, on board the Count Ruggiero' on 16 June 1833. Newman was travelling back from Sicily, where he had been seriously ill, to Marseilles, but 'we were becalmed a whole week in the Straits of Bonifacio'. He occupied himself writing verses, including this, his best-loved poem, which was published in *Lyra Apostolica* (no. 52).

The poem was given numerous musical settings, several of which were collected in a volume preserved at the Birmingham Oratory.

The Fathers of the Birmingham Oratory

23

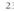

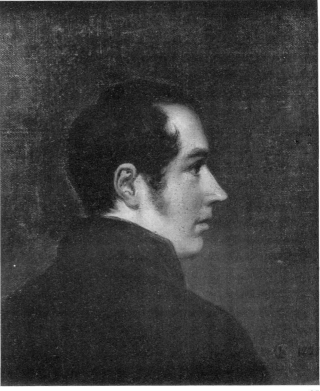

25

II The Two Churches

In the years Newman spent at Oxford, between 1816 and 1845, many factors combined to mould the Church of England into a body very different from the Church of the eighteenth century. Many felt that it would not be possible for it to survive as the established church, and some felt that this would be a good thing.

Two particular areas of pressure on Newman's Church were the situation of Ireland, joined in Union to Britain in 1800 (and with the majority of its population Catholic), and the problem of serving the burgeoning cities in which Nonconformism and indifference to religion were thriving. Irish Catholics were, also, increasingly drawn to English cities such as Birmingham and Liverpool.

Sir Robert Peel and other Tories felt that the alternative to giving Irish Catholics equal civil rights was revolution, so despite the traditional Tory support for the established Church, the Catholic Emancipation Act was passed in 1829. As a result of the Act, Irish Catholics could be elected as MPs sitting at Westminster. This was not however the end of Irish demands for freedom, which were vigorously maintained under Daniel O'Connell (see no. 36), who was immediately elected an MP. Some, like Newman, felt that this signalled the start of the secularization of society, and their feelings were confirmed by attempts to raise money for city churches through dismantling other institutions of the Church thought unnecessary and which could be 'rationalized' or merged, such as bishoprics. Newman came to feel the challenge of bringing the established religion to the cities was being met at the price of undermining the Anglican church.

Following Catholic emancipation, the Roman Catholic Church, under the leadership of Nicholas Wiseman (see no. 25) was making itself increasingly visible in England. This movement ultimately led to the establishment of Catholic bishoprics in England in 1850 when Wiseman became a Cardinal. Traditionally English Catholics had eschewed both baroque magnificence and medieval ritual; now, both were being urged upon them. For the architect and Catholic convert Pugin (see no. 37), architecture which was not Gothic was pagan and unthinkable; he enthusiastically encouraged his patrons such as the Earl of Shrewsbury (see no. 38) to adopt a whole-hearted revival of the full panoply of medieval ritual in worship, as well as medieval architectural fittings, including, most controversially, rood screens. At the same time Anglicans took up similar ideas, and formed bodies such as the Oxford Society for Promoting the Study of Gothic Architecture (see no. 45), with which Newman was briefly associated, and the better-known and more controversial Cambridge Camden Society (see no. 47). Their predilection for the medieval past was encouraged by the emphasis on the teachings of the Early Church and distaste for the Protestant Reformation evident in tracts and sermons by the members of the Oxford Movement, led by Newman.

27 Hannah More 1745–1833

Augustin Edouart, signed and dated 1827

Cut paper silhouette, 22.2 × 27.9 (8¾ × 11)
PROVENANCE: Purchased Sotheby's, 14 October 1966.

Hannah More was one of the most widely read authors of the early nineteenth century, and a leading Evangelist. She was initially prominent as a playwright and friend of Dr Johnson and his circle, and later, after the death of the actor David Garrick, she turned to religious writing and the promotion of education. She wrote numerous religious tracts, as well as other popular works which went into numerous editions, such as *Practical Piety* (1811) and *Coelebs in Search of a Wife* (1809).

Although Newman had been brought up in a household strongly influenced by the Evangelical spirit exemplified by Hannah More, by the 1830s he found her lack of interest in doctrine shocking, and cited the indifference to the creeds demonstrated in her *Life and Letters*, published in 1835 (Ker, p. 119): he thought this neglect of theology, particularly among the clergy, painful and likely to lead to a general defection to Unitarianism. Blanco White, (see no. 20), became a Unitarian in 1835; indeed Hannah More had herself been accused of Unitarian tendencies.

National Portrait Gallery (NPG 4501)

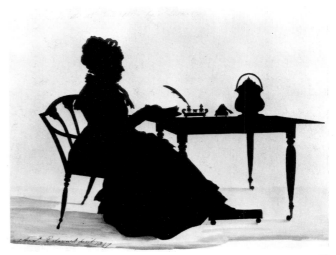

27

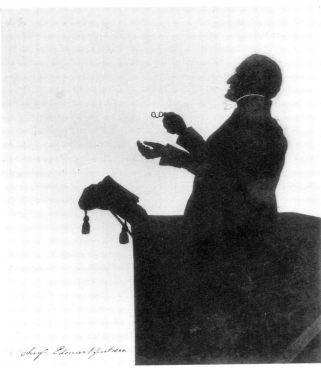

28

28 Charles Simeon 1759–1836

Augustin Edouart, signed and dated 1828

Cut paper silhouette, 23 × 20.3 (8¾ × 7⅝)
PROVENANCE: Purchased Phillips 26 February 1986 (246–9).

Charles Simeon was one of the most influential Evangelical churchmen of the late eighteenth and early nineteenth centuries. His life was spent at Cambridge where he was ordained in 1783, and where he was a Fellow of King's College. He was a founder of the Church Missionary Society in 1797, and responsible for persuading many of his curates to take up mission work in India. A contemporary observed that Simeon's following was 'larger and not less devoted than that which followed Newman'. Newman was strongly influenced by the Evangelicals as a young man but during the 1820s his sympathies began to move in the opposite direction.

Simeon was an important exponent of the art of preaching: his outlines of sermons on the Bible were published from 1796 and collected between 1819 and 1820 in eleven volumes. He was represented by Edouart in a series of silhouettes showing various aspects of preaching: eight half-lengths, of which no. 28 is one, are in the National Portrait Gallery Archive; a ninth, full-length silhouette is known from copies belonging to the Church Pastoral-Aid Society. These copies were supplied with captions indicating the various stages of sermonizing, such as 'imparting', 'expounding' and 'entreating'. (Information kindly supplied by the Bishop of Thetford.)

National Portrait Gallery Archive

29 Archbishop William Howley 1766–1848

William Owen, *c*.1823–5

Oil on canvas, 125.1 × 99.7 (49¼ × 39¼)
PROVENANCE: bought from Hughes & Tillman, Pall Mall, 1909.
LITERATURE: Walker, I, p. 265.

William Howley, Regius Professor of Divinity at Oxford (1809–13), was made Bishop of London in 1813, and Archbishop of Canterbury in 1828. As Archbishop his period of office coincided with proposals for a number of measures which would reduce the standing of the Church of England if implemented; there was a widespread fear among Anglicans that the disestablishment of the Church would follow. Archbishop Howley unsuccessfully opposed the bill for Catholic emancipation in 1829 and the Irish Temporalities Bill in 1833, in which it was proposed to dissolve ten Irish bishoprics, as well as the 1832 Reform Bill , which he thought would be 'dangerous to the fabric of the constitution'. Newman wished Howley 'had somewhat of the boldness of the old Catholic Prelates', although he added, 'no one can doubt he is a man of the highest principle, and would willingly die a Martyr'. (Ker, p. 83)

This is the second of two portraits of Howley by Owen, both painted when he was Bishop of London.

National Portrait Gallery (NPG 1552)

29

30 Charles James Blomfield 1786–1857

W. J. Ward after Samuel Lane, 1827

Mezzotint, 45.7 × 35.6 (18 × 14)

LITERATURE: Ormond I, p. 41.

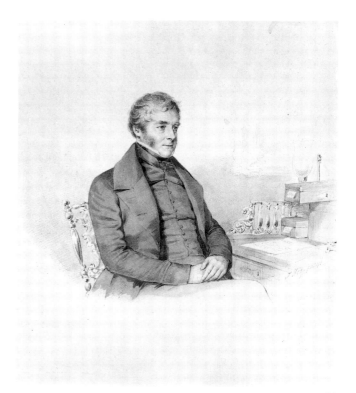

Blomfield, who started his career as a noted classical scholar at Cambridge, became Bishop of London in 1828. In 1835 he was made a member of the Ecclesiastical Commission re-established by Melbourne's government with the aim of redistributing the financial resources of the Church of England to provide more support for the needs of the growing cities. In his role of Bishop of London he was active in providing for increasing numbers of churches, clergy and schools, and established a 'metropolis churches fund'.

Newman said in 1833 that he would decline the Whitehall preachership if Bishop Blomfield were to offer it, because Blomfield had been a supporter of the 1832 Reform Bill (in fact he abstained). They were later to collide over *Tract XC*.

Lane's portrait of Blomfield was taken while he was Bishop of Chester 1824–8, just prior to his appointment as Bishop of London.

National Portrait Gallery Archive

31 William Lamb, 2nd Viscount Melbourne 1779–1848

Samuel Diez, signed and dated 1841

Pencil and wash on paper, 37.8 × 30.5 (14$\frac{7}{8}$ × 12)

PROVENANCE: Sotheby's 27 July 1937 (74); Donald Antiques & Decorations, from whom purchased 1941.

LITERATURE: Ormond I, p. 313.

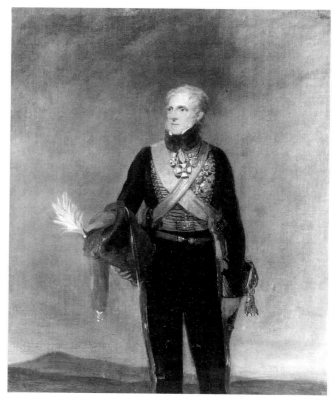

Lord Melbourne was Prime Minister in 1834 and 1835–41, and on the accession of Queen Victoria in 1837 he acted as guide and mentor to the young Queen. Church matters played a large part in his ministries while attempts to reform the Church of England continued under the aegis of the Ecclesiastical Commission established in 1835 (see no. 30) under Sir Robert Peel. Melbourne was widely suspected of being a freethinker and devoid of religious faith, and it was he who was responsible for the appointment of R. D. Hampden as Regius Professor of Divinity at Oxford and the resultant agitation against him (see no. 59) led by Newman, who professed a hatred of Whigs.

National Portrait Gallery (NPG 3103)

32 Henry William Paget, 1st Marquess of Anglesey 1768–1854

William Salter, 1834–40

Oil on canvas, 53 × 43.2 (21 × 17)

PROVENANCE: the artist; bought Edward Mackenzie, 1852; bequeathed by his son William Dalziel Mackenzie to the National Portrait Gallery, 1929; entered collection 1950.

LITERATURE: Walker I, pp. 8, 634–6.

After a highly distinguished military career, culminating in the Battle of Waterloo, where he commanded the cavalry, Lord Anglesey joined the government. In 1828, when

agitation for Catholic emancipation was at its height, he became Lord-Lieutenant of Ireland. He went determined 'not [to] be considered either Protestant or Catholic', and quickly concluded that the Irish Church should be disestablished, and that the resultant revenues should be used to relieve Irish poverty. The Prime Minister, the Duke of Wellington, strongly disagreed, and Anglesey was recalled to England, but the Catholic Emancipation Act was passed in Parliament in 1829. Anglesey was made Lord-Lieutenant again in 1830 by the new Prime Minister, Earl Grey, but then encountered O'Connell's campaign for the repeal of the Union: 'the question is whether he [O'Connell] or I shall govern Ireland' (see no. 36). Anglesey did not succeed in damping down Irish agitation before he left his post in 1833, but he was active in establishing a system of state education with Archbishop Whateley (see no. 19).

Lord Anglesey is shown in his Hussar's uniform; his decorations include his Waterloo medal; this is one of a series of studies for 'The Waterloo Banquet', now at Stratfield Saye House.

National Portrait Gallery (NPG 3693)

33 Sir Robert Peel 1788–1850

John Linnell, 1838

Oil on panel, 45.5 × 37.7 ($17\frac{7}{8}$ × $14\frac{3}{8}$)

PROVENANCE: Commissioned by Thomas Norris; Norris's sale, Christie's 9 May 1873 (30); bought Viscount Cardwell; purchased at Cardwell sale, Christie's 9 May 1887 (201).

LITERATURE: Ormond I, p. 368.

Peel became an MP in 1809 aged twenty-one and soon became embroiled in the Irish question; in 1812 he took up the post of Chief Secretary for Ireland which he held until 1818. His task was to maintain authority and order in the face of opposition from Daniel O'Connell (see no. 36) which he approached by establishing a police force and speaking against Catholic emancipation. His acrimonious relationship with O'Connell resulted in Peel challenging him to a duel in 1815, which never took place, as O'Connell was arrested on his way to meet him.

In 1822 Peel became Home Secretary; he resigned in 1827 when Canning succeeded Lord Liverpol as Prime Minister, because Canning was in favour of Catholic emancipation. He then changed his mind, believing that maintaining order in Ireland took priority, and introduced a bill for Catholic emancipation. He subsequently resigned and sought re-election at Oxford, where he was defeated and earned Newman's disapproval (see no. 30).

Peel was afterwards re-elected elsewhere, and continued his political career, eventually introducing the bill to abolish Irish tithes as well as other church reforms, notably the establishment of the Ecclesiastical Commission in 1835. In 1841 he became Prime Minister, and once more faced the Irish question and O'Connell, now more than ever a crisis because of the potato famine; the suspension of the Corn Laws was one consequence of the situation.

Illustrated in colour on p. 38.

National Portrait Gallery (NPG 772)

THIS SKETCH
Is respectfully dedicated to the
UNIVERSITY OF OXFORD.

Published by J.Dickinson, New Bond Street
Printed by C.Hullmandel

34

34 Sir Robert Peel and Oxford University

John Doyle

Lithograph, 22.2 × 15.6 ($8\frac{3}{4}$ × $6\frac{1}{8}$)

Inscribed 'This sketch/Is respectfully dedicated to the/University of Oxford', this political cartoon refers to Peel's offering himself for re-election as the University MP in 1829, after deciding to support Catholic emancipation (see no. 33), a change of mind greatly deplored by Newman. Peel lost the election.

John Doyle was the author of numerous similar sketches.

National Portrait Gallery Archive

35 Nicholas Wiseman 1802–65

Copyprint from a glass negative by Emery Walker in the National Portrait Gallery Archive after a miniature by François Rochard

In 1835 Wiseman returned from Rome, where he had been Rector of the English College (see no. 25), to England, where Rochard portrayed him in this miniature, exhibited at the Royal Academy in 1836. In England Wiseman delivered a popular and well-received series of lectures on the Principal Doctrines and Practices of the Catholic Church. In 1836 he founded the *Dublin Review* with Daniel O'Connell (see no. 36) and Michael Joseph Quin. Newman recalled in the

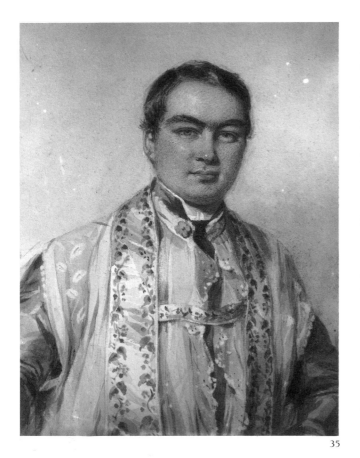

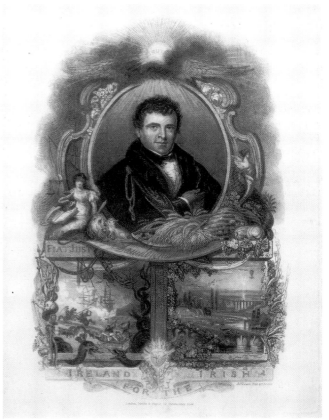

35

36

Apologia (p. 664) how Wiseman's 1839 article on the 'Anglican Claim' in the *Dublin Review* shook his confidence in the legitimacy of the Church of England.

After a brief period in Rome again, Wiseman was in 1840 appointed coadjutor to Bishop Walsh in the Midlands, and made President of Oscott College. He was thus well placed to take issue with the arguments thrown up by the Oxford Movement and called on Newman at Oriel in July 1841.

36 Daniel O'Connell 1775–1847

James Lewis

Engraving, 24.2 × 17.9 (9½ × 7), published Brain and Bayne (undated)

Newman in 1835 confessed he had an 'unspeakable aversion' to O'Connell, the champion of Catholic Ireland, who, he maintained, 'advanced Catholicism by violence and intrigue', (Ker, pp. 118–9) and was prepared to ally himself with anyone against the Anglican church.

A barrister by training, O'Connell campaigned vigorously for the repeal of the Union between England and Ireland and for the removal of all inequalities affecting Irish Catholics. He was elected as MP for County Clare in 1828, before the passing of the Catholic Emancipation Act in 1829, although he did not take his seat until 1830.

In this engraving, one of many popular prints produced featuring O'Connell, the beleaguered and oppressed condi-

tion of Ireland on the left is contrasted with the peaceful abundance of the country on the right, when justice has been done, and Ireland, as the caption proclaims, has been restored to the Irish.

National Portrait Gallery Archive

37 Augustus Welby Northmore Pugin 1813–52

Unknown artist

Oil on canvas, 61.3 × 60.8 (24⅛ × 20)

PROVENANCE: Mr. Pitman of Pitman & Sons (ecclesiastical decorators); J. N. Brown, 1881; purchased from Shepherd's Gallery 1905.

LITERATURE: Ormond I, pp. 386–7.

Pugin, the great champion of the Gothic revival in England, was both architect and designer. He designed furniture and fittings for Wyatville at Windsor Castle, and collaborated with Sir Charles Barry over the design and interior furnishings of the rebuilt Houses of Parliament. His designs for furniture, tiles, stained glass and metalwork were among the most influential of the century, and were carried out in close collaboration with him by manufacturers such as John Hardman who executed Pugin's designs for ecclesiastical metalwork (see no. 94). As an architect Pugin was responsible for the design of numerous churches, including St George's Cathedral, Southwark.

Pugin converted to Roman Catholicism in 1835, and his major patrons, such as the 16th Earl of Shrewsbury (see no. 38) were also Catholics. Pugin was vehement in his insistence that Gothic was the only style of architecture appropriate for the Catholic religion, and that to build churches in any other style was anti-Christian. Pugin's enthusiasm for the trappings of medieval ritual, set out most graphically in his *Glossary of Ecclesiastical Ornament* (no. 44) appealed strongly to those Anglicans who in the 1830s and 1840s were concerned with the authentic revival of Gothic architecture (see nos. 45, 47).

The whole-hearted revival of medieval ritual was a controversial matter, both in the Anglican and the Roman Catholic churches, and arguments came to a head in the late 1840s over the so-called Rood-Screen controversy in which Pugin and his supporters insisted screens should be reinstated in churches, thus separating the clergy and the laity in a manner which many (including Faber of the London Oratory, see no. 86) found contrary to modern ideas of unified worship. Newman sided with those who deplored the screens as an obstruction, and later departed wholly from his earlier admiration for Pugin over the question of the design for his Catholic Oratory (see no. 91) but in 1840 he could write of Pugin 'I can't help liking him, though he is an immense talker'. (Patrick, p. 193)

Illustrated in colour on p. 35.

National Portrait Gallery (NPG 1404)

38 John Talbot, 16th Earl of Shrewsbury 1791–1852

J. Morrison after Octavius Oakley

Engraving, 22.9 × 14.4 (9 × 5$\frac{11}{16}$), published by Fisher Son & Co., London, 1847

The 16th Earl of Shrewsbury belonged to an old Roman Catholic family and was one of the major patrons of the Gothic revival, and in particular of Pugin (see no. 37), whom he discovered in 1832. He commissioned a number of works from him, including the chapel at his home, Alton Towers, (see nos. 39, 40 and 41), and the nearby St Giles, Cheadle, admired by Newman (see no. 39). He greatly encouraged the building of new Catholic churches, and made numerous donations to them.

National Portrait Gallery Archive

39 Alton Towers

Photograph, 1951

LITERATURE: C. Hussey, *Country Life*, 127, January–June 1960, pp. 1304–7.

The Roman Catholic 16th Earl of Shrewsbury (see no. 38) enlisted the help of Pugin (see no. 37) for the completion of his family seat at Alton, which the 15th Earl had begun. Much of the architecture was probably the work of Robert Abraham (1774–1850), and Pugin was responsible for the interior decorations, principally of the hall and chapel, although the large oriel window (to the left in the photograph) was probably his work.

Pugin was at work at Alton between 1837 and 1840; he provided an equestrian figure of his patron's ancestor, the 'Grand Talbot', 1st Earl of Shrewsbury, wearing full armour, as well as numerous decorative finishes: moulded plaster, painted ceilings, stencilled walls and a wrought iron staircase. In the chapel he was responsible for a similar decorative scheme, and for the design of the stained glass windows which were made by Thomas Willement.

Newman visited Alton Towers in April 1846 not long after his conversion, and described the nearby church of St Giles, Cheadle, designed by Pugin in richly decorated Gothic style and paid for by the 16th Earl of Shrewsbury as 'the most splendid building I ever saw'. (Quoted by Patrick, p. 198)

40 Carved wooden angel designed by A. W. Pugin for Alton Towers Chapel

Illustrated in colour on p. 37.

National Portrait Gallery

41 Tiles designed by A. W. Pugin for Alton Towers Chapel

National Portrait Gallery

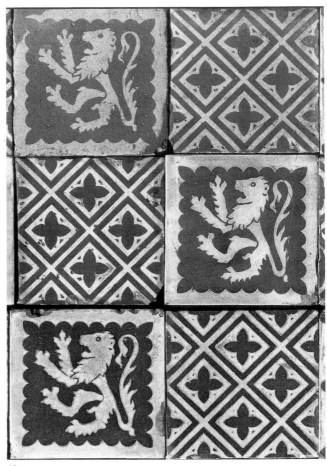

41

42 Thomas Rickman, 'An Attempt to discriminate the Styles of Architecture from the Conquest to the Reformation' 2nd edition, 1819

Book, 22.2 × 14.2 (8¾ × 5 1/10)
LITERATURE: *Victorian Church Art*, p. 6.

Rickman's book was the first attempt to characterize the different styles of English Gothic architecture using the now familiar terms 'Norman', 'Early English', 'Decorated' and 'Perpendicular', and marks a turning point in attitudes towards the Gothic style. In the latter part of the eighteenth century and the early nineteenth century, the 'Gothick' style had become popular first in antiquarian circles, and then more widely; many country houses were built which evoked medieval architecture, in a generally fanciful manner, such as Strawberry Hill.

Rickman's studies are an indication of the more serious approach to Gothic architecture adopted in the nineteenth century. Thomas Rickman (1776–1841) was a self-taught architect who came to architecture late in life and who undertook the design of a large number of the new churches which were urgently needed by the Church of England in the early nineteenth century. Following a business failure, Rickman developed a scholarly interest in medieval architecture and set out to classify the details he recorded from his own observations during long country walks. The resultant book was first published in *Smith's Panorama of Arts and Sciences* (Liverpool, 1812–15); its appearance as a separate publication in 1817 was highly successful and the book went through several editions. Rickman's drawings of architectural details were purchased on his death for £25 by the Oxford Society for Promoting the Study of Gothic Architecture (see no. 45).

Lent by Jane and Clive Wainwright

43 Matthew Holbeche Bloxam, 'The Principles of Gothic Architecture elucidated by Question and Answer' 5th edition, London, 1843

Book, 18.2 × 11 (7 1/10 × 4¼)
LITERATURE: Dictionary of National Biography.

The antiquary Matthew Holbeche Bloxam (1805–88) was the elder brother of John Rouse Bloxam (1807–91), Newman's curate at Littlemore Church (1837–40) (see nos. 75, 77), and a fellow-enthusiast for the revival of Gothic architecture. Both brothers were members of the Oxford Society for Promoting Gothic Architecture (see no. 45).

M. H. Bloxam's book first published in 1829, when its author was only twenty-four, was a pioneering work in the Gothic revival, along with Rickman's *Styles of Architecture* (no. 42) on which Bloxam was able to draw for his own work. The number of editions which appeared testified to its importance and influence as a text book on the subject. The question and answer format was abandoned in the sixth edition of 1844.

Lent by Jane and Clive Wainwright

44 A. W. Pugin, 'The Glossary of Ecclesiastical Ornament and Costume' 3rd edition, London, 1848

Book, 33.3 × 26.2 (13 1/16 × 10 5/16)
LITERATURE: *Victorian Church Art*, p. 1, no. B10; Belcher, pp. 77–82.

Pugin's book, first published in 1844, was an exemplar of the faithful revival of medieval ecclesiastical furnishings which its author wished to promote as vigorously as possible (see no. 37). It is also 'one of the finest early examples of chromolithography'; and the use of brilliant colour in church decoration was essential to Pugin's purpose. The book contains numerous examples of pure pattern in different combinations of colour, which could be used as inspiration for wall decoration, tiles or other features of a decorative scheme, as well as detailed illustrations of vestments and church fittings. The review of the book in the journal of the Camden Society (see no. 47), the *Ecclesiologist* (vol. III, 1844, pp. 142–3) referred to the novelty of using colour in churches and concluded 'it is impossible to look through the illustrations of this volume without admiring that splendid effect; and it is equally impossible to admire them, and then to call to mind that they are designed for church work, without longing to introduce them into our churches'.

Pugin was assisted in the preparation of his text by Bernard Smith, a friend of J. R. Bloxam (see no. 75). Smith's conversion to Roman Catholicism in 1842 led to the accusation that Newman had encouraged him to retain his Anglican living in Lincolnshire, which Newman denied.

Illustrated in colour on p. 34.

Lent by Jane and Clive Wainwright

45 'Proceedings of the Oxford Society for Promoting the Study of Gothic Architecture' Oxford, 1840

Book, 22.5 × 14.2 (8⅞ × 5¾)

The Oxford Society for Promoting the Study of Gothic Architecture held its first General Meeting on 12 March 1839. At the meeting the 'usefulness of such a society' was noted, 'especially in this place, where so many young men are preparing for Holy Orders, who ought to consider some knowledge of Gothic Architecture as almost an essential part of their education'. In the preamble to the Society's rules it was stated: 'The number of Churches now fast rising in every part of the country, render it of the highest importance to provide for the cultivation of correct Architectural Taste', and the Society set out to be one of a number of local associations which needed to be established to document the 'Gothic antiquities of any particular district'; the similar but better-known Camden Society of Cambridge was also established in 1839 (see no. 47).

Early members included J. R. and M. H. Bloxam (see nos. 75, 43) as well as Francis Faber, brother of Frederick (see no. 86), the undergraduate John Ruskin (see no. 46) and the architect Thomas Rickman (see no. 42); Newman was not a member, although it has been stated that he was, probably

because a 'W. J. Newman BA' of Oriel was a member. By 1843 the membership had greatly increased and the Society owned a considerable number of engravings, casts, models, brass rubbings and drawings (it bought Rickman's in 1842) as well as a considerable library kept by the bookseller J. H. Parker on his premises in Broad Street, Oxford. The library included two volumes donated by John Henry Newman shortly after the Society's foundation, the gift being recorded in the minutes of the meeting of 10 May 1839. The books were J. Carter's *Specimens of Ancient Sculpture and Painting in England* (1838), and *Essays on Gothic Architecture for the use of the Clergy of his Diocese* by J. H. Hopkins, an American publication (1836).

Society of Antiquaries of London

46 John Ruskin 1819–1900

George Richmond

Chalk on paper, 43.2 × 35.6 (17 × 14)

PROVENANCE: George Richmond; acquired from his executors, 1896.

Ruskin was an undergraduate at Christ Church, Oxford, between 1837 and 1840, when the Oxford Movement was at its most influential. He came from a Scottish Calvinist family, and was apparently uninfluenced by the Tractarian cause, but he was already keenly interested in architecture, and was a founder member of the Oxford Society for Promoting the Study of Gothic Architecture (see no. 45).

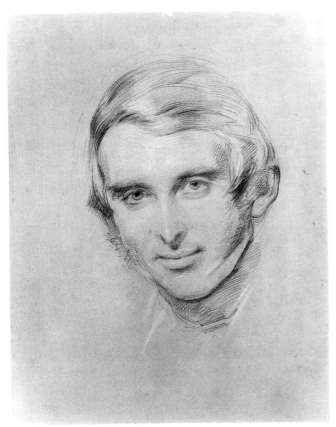

Ruskin's *Seven Lamps of Architecture*, published in 1849 after his reputation had been made with the first volumes of *Modern Painters*, was an important and highly individual contribution to the literature of the Gothic revival. This drawing was executed in about 1843 (at almost the same time that Richmond portrayed Newman [no. 68]); Ruskin had recently returned from a European tour undertaken for his health.

National Portrait Gallery (NPG 1058)

47 'A Handbook of English Ecclesiology' published by the Ecclesiological late Cambridge Camden Society, 1847

Book, 15 × 10.4 ($6\frac{1}{16}$ × 4)

The Cambridge Camden Society first met in May 1839, just after the foundation of the Oxford Society for Promoting the Study of Gothic Architecture (see no. 45). Its aims were similar, although the Cambridge Society was to be much more of a campaigning body, through its journal *The Ecclesiologist*, and was scornful of the more cautious attitudes towards restoration of Gothic churches expressed in the proceedings of the Oxford Society.

The Cambridge Society was more exclusively concerned with churches than the Oxford Society, and first published *A Few Hints on the Practical Study of Ecclesiastical Antiquities for the Use of the Cambridge Camden Society* in the 1840s. This was superseded by the expanded version, the *Handbook*, a 'pocket companion to church visits'. The Camden Society devised the 'Church Schemes', a checklist for visitors to Gothic churches to be used to make a complete record of all the architectural features of any church visited; the records were held by the Society to form an extensive and comprehensive archive of records of medieval church building. The *Handbook* provided all the necessary background information needed for the users of the 'Church Schemes'.

Lent by Jane and Clive Wainwright

46

III The Oxford Movement 1833–45

'My battle was with liberalism', Newman wrote in the *Apologia*, recounting the origins of the Oxford Movement. He joined with his fellow Oriel College dons, John Keble and Edward Bouverie Pusey, to publicize in a series of tracts, in their sermons and in every other possible manner, their view that the country was on the way to 'national apostasy': if action were not taken, England would become a secular country with no national church; the way to stop the rot was to emphasize the inheritance of the early and medieval Church, rather than that of the post-Reformation Church. In the course of this battle, there were several minor skirmishes; with Renn Dickson Hampden (see no. 59), who was appointed Regius Professor of Divinity at Oxford in 1837, to the horror of Newman and his friends, who deplored his liberal views; and with Sir Robert Peel (see no. 33), whose proposal for a public library at Tamworth Newman attacked in 1841 in his most dazzling and scornfully satirical prose, on the grounds that Peel was promoting secular knowledge at the expense of the divine (see no. 60). 'Wonder is not religion', Newman wrote, 'or we should be worshipping our rail roads'.

In 1841 Newman published the now notorious *Tract XC*, on the subject of the Thirty-nine Articles, which brought the full force of the Church's authority down on him. Newman argued that the Articles, set down under Elizabeth I after Henry VIII's break with Rome, and overtly Protestant in much of their expression, were compatible with the doctrines which he believed were inherited from the Early Christian Church and were close to, but differentiated from, Roman Catholic beliefs. *Tract XC* was thought at best casuistical; at worst, overtly papist. Newman wrote that from the end of 1841 'I was on my deathbed as regards my membership with the Anglican Church'.

In the aftermath of the controversy Newman retired to his parish at Littlemore. He found it difficult to avoid public gaze, however, as his admirers flocked to join him at the converted cottages where he led a semi-monastic community (see no. 78). Some of them converted to Roman Catholicism, which brought increased opprobrium to Newman. By 1845 his mind was made up, and the Italian priest Father Dominic Barberi received him into the Roman Catholic Church on 9 October.

48 John Keble 1797–1866
George Richmond, 1843

Watercolour on paper, 45 × 29 (17¾ × 11½)
PROVENANCE: Lord Coleridge; bought Christie's 11 April 1967 (142).
LITERATURE: Ormond I, p. 247.

Keble, Newman's senior by nearly a decade, had been elected a Fellow of Oriel with Whateley (see no. 19) in 1811. He was ordained in 1816, and in 1823 resigned his tutorship to devote himself to being an unworldly country clergyman at Fairford where he wrote the poems published in 1827 as the highly successful *Christian Year* (no. 49). In 1831 he was elected Professor of Poetry at Oxford.

Keble and Newman were not at first close as Newman was still regarded as having Evangelical sympathies, but according to the *Apologia*, 'Hurrell Froude brought us together about 1828' and Newman stayed with Keble in that year. In 1828 Keble was a candidate with Edward Hawkins (see no. 17) for the Provostship of Oriel; when Hawkins was elected, with Newman's support, Newman remarked they were 'not electing an Angel, but a Provost'. (Ker, p. 31)

Keble's *Assize Sermon* on National Apostasy (no. 50), marked the beginning of the Oxford Movement for Newman, and in September 1833 Keble joined with Newman to issue the first *Tracts for the Times*.

The portrait is listed in Richmond's account book (photostat in National Portrait Gallery Archive).

The Warden and Fellows of Keble College, Oxford

49 John Keble, 'The Christian Year'
Oxford, 1827

Book, 18.2 × 12 (4¾ × 7⅛)
LITERATURE: Chadwick I, pp. 66–8.

Keble began writing his *Thoughts in Verse for the Sundays and Holydays throughout the Year* in 1819, and completed them by 1825. In the preface he wrote: 'The object of the present publication will be attained if any person find assistance from it in bringing his own thoughts and feelings into more entire unison with those recommended and exemplified in the Prayer Book'. The verses were short, lyrical poems, published anonymously in 1827. They were not intended as hymns, which were sung only by evangelical Christians, but as bedside comfort. Newman thought them 'exquisite' and when his sister Mary (see no. 11) was dying in 1828 she was comforted by reading some of the poems she had learned by heart from a copy bought by Newman. (Ker, pp. 33–1) In the *Apologia* Newman claimed that Keble 'struck an original note and woke up in the heart of thousands a new music, the music of a school long unknown in England'. (p. 592)

The British Library Board (994a 36)

50 John Keble, Assize Sermon, 'National Apostasy Considered' Oxford, 1833

Book

In the *Apologia*, Newman declared that he considered the day Keble preached the Assize Sermon, 14 July 1833, 'as the start of the religious movement of 1833'. (p. 604)

Keble's sermon, preached in the University pulpit (see no. 53), was of personal significance to Newman (the pages of Pusey's copy of it remained uncut [Chadwick, p. 70]) rather than a generally recognized starting-up of the Oxford Movement, but the theme which Keble took up in his sermon, that of 'National Apostasy' was central to the Oxford Movement and its cause. Keble argued that the position of the Church of England was being eroded by the reforms recently passed by Parliament, as well as by the current proposals to abolish bishoprics in Ireland; he deplored the interference of government in church affairs and the development of an increasingly secular society, which lacked respect for the bishops of the church, the successors of Christ's Apostles.

The Fathers of the Birmingham Oratory

51 Edward Bouverie Pusey 1800–82

Engraving, 24.9 × 17.6 (9$\frac{13}{16}$ × 6$\frac{7}{8}$), published by Wyatt & Son, Oxford

Pusey was elected a Fellow of Oriel in April 1823. Newman later described Pusey as he knew him then: 'His light curly head of hair was damp with the cold water which his headaches made necessary for comfort; he walked fast with a young manner of carrying himself, and stood rather bowed, looking up from under his eye-brows, his shoulders rounded'. (Quoted by Ker, p. 19) Newman and Pusey joined a class run by the Regius Professor of Divinity, Charles Lloyd, to supplement the public lectures. As a result of this class, Pusey spent two years from 1825 in Germany, where he studied Hebrew and Oriental languages in order to engage with the scholarly challenge to orthodox beliefs coming from German scholars who were studying the Bible as an historical text and finding much in it unproven. In 1827 he published *An Historical Enquiry into the Probable Causes of the Rationalist Character lately predominant in the Theology of Germany*, and in 1828 he was appointed Regius Professor of Hebrew at Oxford.

When Newman began publishing the series *Tracts for the Times*, in 1833, Pusey thought few people would read them, and it was not until 1835 that he began to join in whole-heartedly, contributing several tracts in 1835 and 1836. In 1836–7 he strongly opposed the election of R. D. Hampden as Professor of Theology (see no. 59) and wrote pamphlets against the proposal. He also wrote vigorously in support of the Tracts, including *Tract XC*.

This engraving entitled 'A Recollection' is of a type similar to those of Newman published in 1841 (see nos. 55, 56).

National Portrait Gallery Archive

LYRA
APOSTOLICA.

Γνοῖεν δ᾽, ὡς δὴ δῆρον ἐγὼ πολέμοιο πέπαυμαι.

EIGHTH EDITION.

LONDON:
JOHN & CHARLES MOZLEY, PATERNOSTER ROW;
AND F. & J. RIVINGTON, ST. PAUL'S CHURCH YARD.
1848.

52

52 John Henry Newman and others, 'Lyra Apostolica' 8th edition, London, 1848

Book, 15.2 × 10.8 (6 × 4$\frac{1}{4}$)

The poems in *Lyra Apostolica* by Newman, which include 'Lead Kindly Light' (see no. 26), were almost all written during his Mediterranean tour in 1832–3. The poems, first published in the *British Magazine*, were conceived as an adjunct to the *Tracts for the Times*, and 'undertaken with a view of catching people when unguarded' (Ker, p. 87); they take as their themes the religious crisis of the period. The authors of the poems are identified only by Greek letters of the alphabet: of the 179 poems, 109 are by Newman (these are by far the most distinguished compositions), 46 by Keble and a smaller number are by Froude, who lacked Newman's easy lyricism.

The Fathers of the Birmingham Oratory

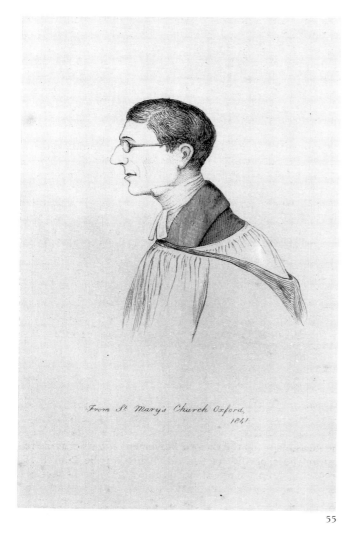

From St Mary's Church Oxford, 1841

55

54 Newman Preaching at the University Church of St Mary the Virgin, Oxford

Copyprint after a watercolour at Magdalen College, Oxford

The original watercolour, preserved in the papers of Newman's curate, J. R. Bloxam, is one of a number of caricatures of Newman which appear to have been made in about 1840–1, when the controversies surrounding the Oxford Movement were at their height; some were engraved for a wider circulation (see nos. 55, 56). All depict Newman in profile.

In a letter to Maria Giberne of 13 April 1842 Newman replied to her request to take a true likeness to take the place of the caricatures then circulating: 'You talk of scarecrows – I have not seen them so my imagination is not affected – but tastes differ – how do you know that many persons would not think *me* the scarecrow, and my caricature an improvement'. (Quoted by Trevor, pp. xiii–xiv)

55 Newman Preaching

(i) From St Mary's Church, Oxford, 1841
Engraving, 17.5 × 11.3 ($6\frac{7}{8} \times 4\frac{3}{8}$)
(ii) A Sketch from Memory, March 1841
Engraving, 17.7 × 11.5 ($6\frac{15}{16} \times 4\frac{9}{16}$)
Published by Wyatt & Son, Oxford

Two of several representations of Newman preaching published at the height of the Oxford Movement controversies. No. 55(i) appears to be after an original sketch formerly in Littlemore Church (photograph in National Monuments Record). A pencil sketch at Oriel College (signed *HBB 27th Sept 1842*) is close to no. 55(ii), but the dating of the print would appear to preclude it from being the original.

The historian, J. A. Froude (see no. 118) described Newman's appearance at this time (Bloxam papers I, p. 80): 'He was above the middle height, slight and spare. His head was large, his face remarkably like that of Julius Caesar. The forehead, the shape of the ears and nose were almost the same. The lines of the mouth were very peculiar, and I should say exactly the same'.

National Portrait Gallery Archive

56 Newman Preaching

T. H. Green, 1841

Lithograph, 17.5 × 11.3 ($6\frac{3}{8} \times 4\frac{3}{8}$)

The original drawing is apparently at Truro Cathedral (Ormond I, p. 340).

National Portrait Gallery Archive

57 Richard Hurrell Froude's 'Breviary' ('Breviarum Romanum') Vol. 1, Antwerp, 1823

Book, 14.3 × 8.9 ($5\frac{5}{8} \times 3\frac{1}{2}$)

Richard Hurrell Froude (1803–36) was elected a Fellow of Oriel in 1826 and was a tutor until 1830. He was ordained in 1829. Froude's admiration for the medieval church and dis-

53 Newman's pulpit at St Mary the Virgin, Oxford

O.M.H., signed and dated 1927

Watercolour on paper, 41.3 × 26.5 ($16\frac{1}{4} \times 10\frac{3}{8}$)

As Vicar of the University Church, Newman was a frequent preacher, and his sermons were highly popular. Matthew Arnold (see no. 133) wrote of 'the charm of that spiritual apparition, gliding in the dim afternoon light through the aisles of St Mary's, rising into the pulpit, and then, in the most entrancing of voices, breaking the silence with words and thoughts which were a religious music, – subtle, sweet, mournful'. (Ker, p. 90) The emphasis on the central placing of the pulpit in the church (see no. 23(ii)) was characteristic of the early nineteenth century Church before the revival of medieval ritual, and contrasts with the emphasis at Littlemore Church on the altar (see no. 75).

The Fathers of the Birmingham Oratory

57

REMAINS

OF THE LATE REVEREND

RICHARD HURRELL FROUDE, M.A.

FELLOW OF ORIEL COLLEGE, OXFORD.

Se sub serenis vultibus
Austera virtus occulit,
Timens videri, ne suum,
Dum prodit, amittat decus.

IN TWO VOLUMES.

VOL. I.

LONDON:
PRINTED FOR J. G. & F. RIVINGTON,
ST. PAUL'S CHURCH YARD,
AND WATERLOO PLACE, PALL MALL.

1838.

58

taste for the Protestant Reformation had a strong influence on Newman; they had 'the closest and most affectionate friendship' from about 1829. (*Apologia*, p. 596).

Joseph Blanco White (see no. 20), the former Catholic priest, recorded in his Journal how, on 31 October 1827, Pusey (see no. 51), Robert Wilberforce and Froude 'came in the evening to learn the order of the Roman Catholic Service of the Breviary, the Catholic Prayer Book (Bloxham papers I, p. 69).

Froude's *Breviary*, a four-volume edition published in Antwerp in 1823, passed to Newman on his friend's death: it was his choice as a memento. Newman recorded this in an inscription on the flyleaf with his name and the date March 12, 1836. Newman used the Breviary every day after acquiring it, although he recorded that it took three or four hours a day to say the Latin offices (Ker, p. 145). He was still using it at the time of writing the *Apologia* (no. 120) in 1864, and it remained in his room at the Oratory on his death.

The Fathers of the Birmingham Oratory

58 'Remains of the late Reverend Richard Hurrell Froude, M.A.' Vol. I, London, 1838, edited by John Henry Newman

Book, 21.5 × 14.3 (8½ × 5⅝)

LITERATURE: Chadwick I, pp. 112–7.

The death of Froude in 1836 (see no. 57), was a severe blow to Newman. As well as being a great friend, Froude was also a tremendous source of inspiration for Newman in developing the ideas inspiring the Oxford Movement and its crusade to restore the centrality of Catholic beliefs to the Church of England. When Froude's father, the Archdeacon of Totnes, sent Froude's papers to Newman and said he would pay the costs of publication, Newman eagerly undertook the task of editorship, and the first two volumes of the four were published in 1838.

The first volume contained Froude's journal, recording his fasting and other mortifications, letters and 'Private Thoughts', which contained declarations of hatred towards the Protestant Reformation and the Reformers (including the English Martyrs Cranmer, Ridley and Latimer). Newman had anticipated a scandal on publication but felt not only that the publication would enable Froude to receive due credit for the ideas of the Oxford Movement, but that the book would show him as a 'saint', and would provide inspiration to others. A scandal duly arose, the controversy surrounding the *Tracts for the Times* and the hostility towards its authors increased, with a consequent rise in sales. The feelings of outrage created by the publication of Froude's views on the martyrs of the Protestant Reformation were however assuaged by the University through the building of the Martyrs' Memorial (see no. 66).

The Fathers of the Birmingham Oratory

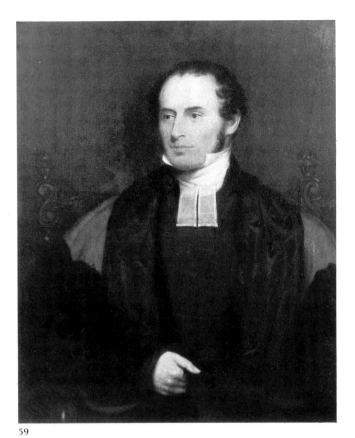

59

59 Renn Dickson Hampden 1793–1868

Attributed to H. W. Pickersgill

Oil on canvas, 88.9 × 69.8 (35 × 27½)

PROVENANCE: Given by the sitter.

LITERATURE: Lane Poole III, p. 100.

Hampden, a Fellow of Oriel and contemporary and friend of Arnold (see no. 21) and Whateley (see no. 19), had returned to Oriel as a tutor after a period as a curate and writer, and in 1832 was elected Bampton lecturer; in 1833 he was made principal of St Mary Hall, where he greatly raised the standard of undergraduate teaching. In 1836 William IV, advised by the Prime Minister, Lord Melbourne (see no. 31) offered Hampden the post of Regius Professor of Divinity; this caused a storm amongst those who maintained Hampden's religious views were unorthodox, including Newman, Keble and Pusey, but also some Evangelicals. They were supported by the opponents of Melbourne's government.

The Bampton lectures which Hampden had delivered in 1832 were the focus of attention: his opponents thought that the lectures emphasized the scriptures at the expense of the authority of the church. Newman wrote overnight a pamphlet, *Elucidations of Dr Hampden's Theological Statements*, which was published anonymously on 13 February 1836; Hampden was sent a copy. Newman wrote to a friend, Simeon Lloyd Pope, that Hampden was worse than a Socinian or Unitarian: 'There is no doctrine, however sacred, which he does not scoff at . . . the man, *judging from his writings*, is the most lucre long [*sic*], earthly minded, unlovely person one ever set eyes on'. (Ker, p. 126)

A petition with seventy-three signatures was sent on 10 February 1836 to Archbishop Howley to be presented to William IV; the petitioners did not know that the King had already sanctioned the appointment. Melbourne told the King he could not change his mind and Hampden's appointment went ahead, accompanied by undergraduate disorder and attempts to restrict Hampden's exercise of his position. Although Newman's campaign failed in its object, it attracted much support in Oxford and therefore put the Tractarians in a strong position; it also showed the Whig government as weak.

In 1847 Lord John Russell (see no. 97) proposed to appoint Hampden as Bishop of Hereford, which caused further controversy. By this time, Newman and many others had joined the Roman Catholic church, a course of which Hampden highly disapproved.

The portrait shows Hampden wearing his robes as a Doctor of Divinity.

The Governing Body, Christ Church, Oxford

60

60 John Henry Newman, 'The Tamworth Reading Room' 1841

Autograph manuscript

The Tamworth Reading Room was first published in the form of seven letters in *The Times* in February 1841, signed by 'Catholicus'. The inspiration for Newman's brilliant satirical work was the speech made in January by Sir Robert Peel (an

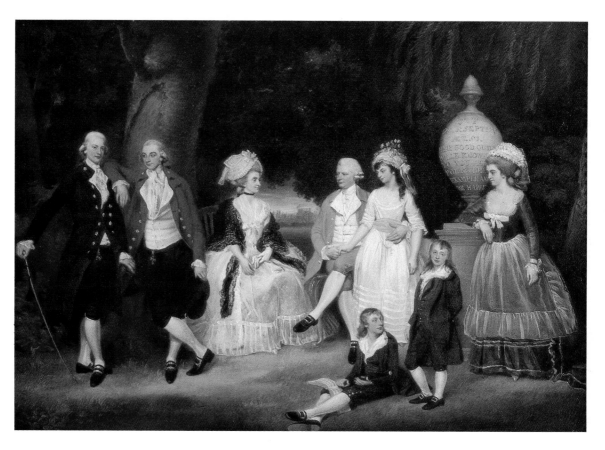

(*Above*) The Fourdrinier Family by John
Downman (no. 1)

(*Right*) John Henry Newman by George
Richmond (no. 68)

Final page of *The Glossary of Ecclesiastical Ornament* by Augustus Welby Northmore Pugin (no. 44)

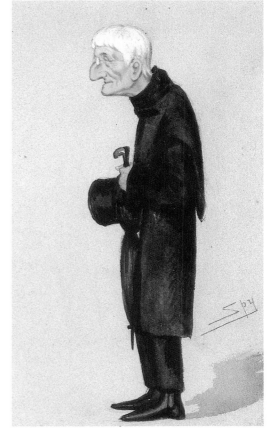

(*Right, top*) John Henry Newman by H.J. Whitlock (no. 139)

(*Right, bottom*) John Henry Newman by Sir Leslie Ward ('Spy') (no. 127)

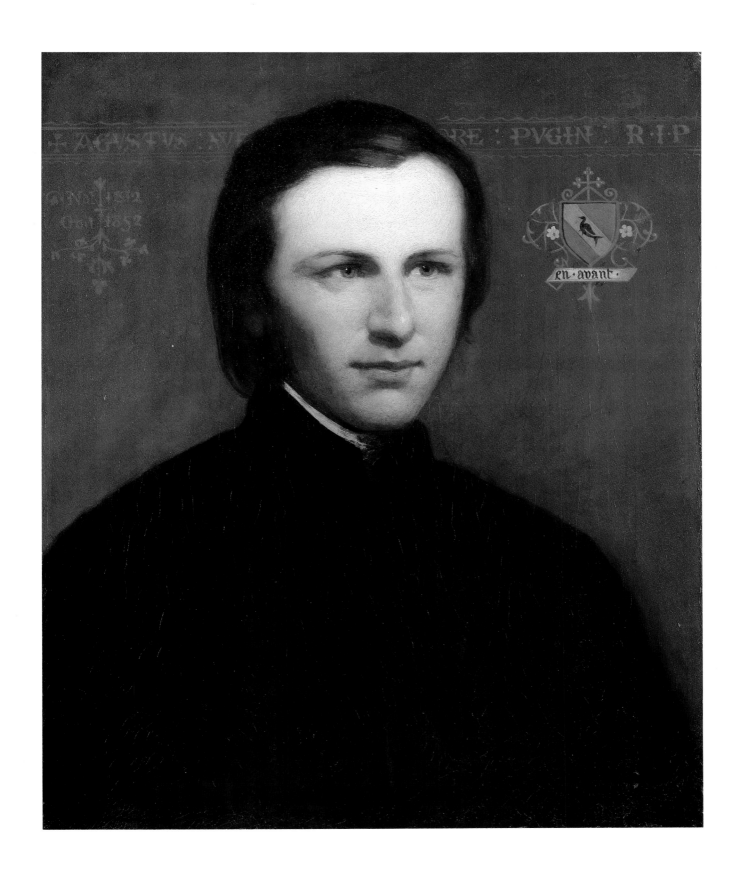

Augustus Welby Northmore Pugin by an unknown artist (no. 37)

(*Above*) John Henry Newman
and Ambrose St John at Rome
by Maria Giberne (no. 81)

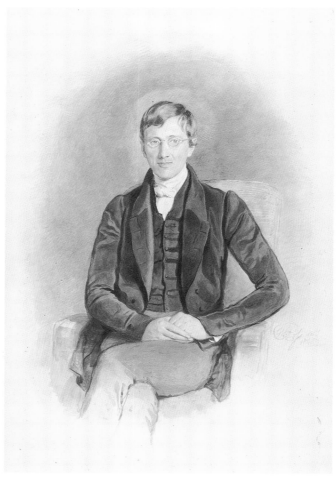

(*Right*) John Henry Newman by
Sir William Ross (no. 70)

Jan 17. 1865

The Dream of Gerontius.

Gerontius. Jesu Maria! I am near to death,
And Thou art calling me; I know it now.
Not by the token of this faltering breath,
This chill at heart, this dampness on my brow,
— Jesu, have mercy! Mary, pray for me! —
'Tis this new feeling, never felt before,
— Be with me, Lord, in my extremity! —
That I am going, that I am no more.
'Tis this strange innermost abandonment,
— Lover of souls! great God! I look to Thee, —
This emptying out of each constituent
And natural force, by which I come to be.
＋Pray for me, O my friends; a visitant
Is knocking his dire summons at my door,
The like of whom, to scare me and to daunt,
Has never, never come to me before.
'Tis death, — O loving friends, your prayers, — 'tis he!

As though my very being had given way,
As though I was no more a substance now,
And could fall back on nought to be my stay,
— Help, loving Lord! Thou my sole Refuge, Thou, —
And turn no whither, but must needs decay
And drop from out this universal frame
Into that shapeless, scopeless, blank abyss,
That utter nothingness, of which I came,
This is it that has come to pass in me,
O horror! this it is, my dearest, this,
So pray for me, my friends, who have not strength to pray.

Assistants. Kyrie eleison, Christe eleison, Kyrie eleison.
Holy Mary, pray for him.

(*Above*) Fair copy of *The Dream of Gerontius* by John Henry Newman
(no. 171)

(*Right*) Carved wooden angel designed by Augustus Welby Northmore
Pugin (no. 40)

(*Above, left*) Sir Robert Peel by
John Linnell (no. 33)

(*Above, right*) John Henry
Newman by Maria Giberne
(no. 83)

(*Right*) John Henry Newman by
Sir William Ross (no. 71)

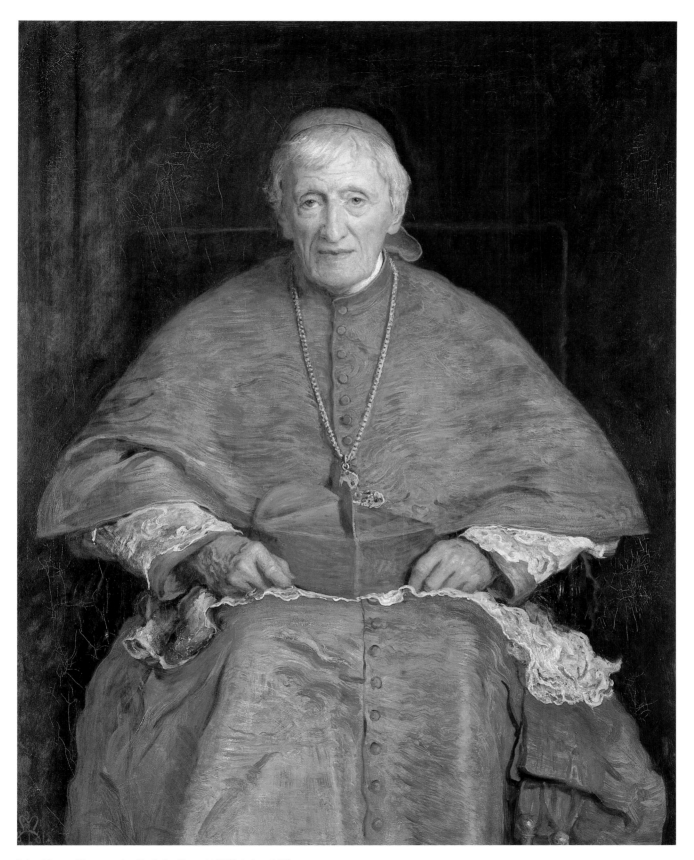

John Henry Newman by Sir John Everett Millais (no. 143)

(*Above*) Mitres by Romanini of Rome and
crozier (nos. 102 and 103)

(*Right*) Morse (no. 104)

61

62

old enemy, see nos. 33, 34) at the opening of a new library and reading-room in his constituency at Tamworth. Newman was persuaded by the proprietor of *The Times*, John Walter, whose son he had taught at Oxford, to write a reply. The letters were published as a book in 1841.

Newman attacks both Peel and Lord Brougham, the former Lord Chancellor and founder of University College London (see no. 61): the two are yoked together and pilloried for their view that knowledge rather than religious faith is the 'fulcrum of society'. Newman wrote: 'wonder is not religion or we should be worshipping our railroads . . . Christianity, and nothing short of it, must be made the element and principle of all education . . . But if we commence with scientific knowledge and argumentative proof, or lay any great stress upon it as the basis of personal Christianity, or attempt to make man moral and religious by Libraries and Museums, let us in consistency take chemists for our cooks, and mineralogists for our masons'. Newman's brilliant argumentative prose, with its combination of lucid control and forceful, vivid, down-to-earth examples was ideally suited to its satirical purpose. In 1870 Newman described the letters as 'written with a freshness and force I cannot now command'.

The Fathers of the Birmingham Oratory (MS D.16.1)

61 Henry Brougham, 1st Baron Brougham and Vaux, 1778–1868, with Sir Robert Peel, 1788–1850

Jemima Wedderburn, 1844

Watercolour on paper, 11.9 × 15.1 ($4\frac{5}{8}$ × 6)

PROVENANCE: By descent to the Misses Mary and Jane Clerk; presented by them to the Gallery, 1935.

LITERATURE: Ormond I, p. 370.

Lord Brougham, who had defended Queen Charlotte in her trial in 1821, was made Lord Chancellor in 1830. At this period he took a strong interest in educational projects, and was responsible for the foundation of London University in 1828, as well as for the Society of the Diffusion of Useful Knowledge; it was because of this interest that Lord Brougham was satirized, along with Sir Robert Peel, also shown in no. 61, by Newman in his *Tamworth Reading Room* (no. 60). The drawing is inscribed below 'Sir Robert Peel showing his pictures. Whitehall Gardens'.

National Portrait Gallery (NPG 2772)

62 John Henry Newman, 'Tract XC', 'Remarks on Certain Passages in the Thirty-nine Articles' Oxford, 1841

Book, 21.5 × 14.3 ($8\frac{1}{2}$ × $5\frac{5}{8}$)

The reaction to the anonymous publication of the ninetieth in the series of *Tracts for the Times* on 27 February 1841 marked a turning point in both the Oxford Movement and Newman's life. The subject of the Tract was the Thirty-nine Articles, which were originally published in 1563, during the reign of Elizabeth I, as a statement of the

64

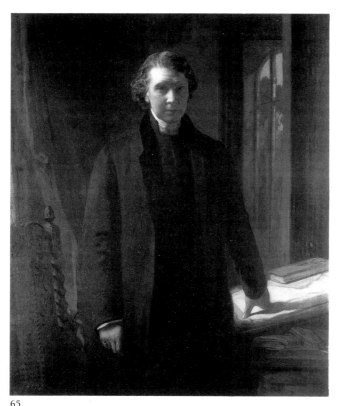

65

doctrine of the Church of England (see Introduction to Section III).

Newman felt that modern interpretation of the Articles obscured the true position of the Anglican church as the repository of the teachings of the historical, apostolic, Catholic church. He therefore argued in *Tract XC* that it was possible to interpret the Articles, apparently containing staunchly Protestant statements, in such a way as to reconcile them with the doctrines of the 'Catholic' church, a church which had rejected papal authority but not Catholic beliefs. As Newman wrote in the *Apologia*, 'Man had done his worst to disfigure, to mutilate, the old Catholic Truth; but there it was in spite of them, in the Articles still'.

Newman did not anticipate that his arguments would cause particular controversy, especially as there had been debates over the validity of the Thirty-nine Articles and the need to subscribe to them in the previous year, and even a proposal by Whateley (see no. 19) to change them (from which Newman disassociated himself). With *Tract XC*, however, the opponents of the Oxford Movement, and even those who had not openly opposed it up to that point, felt things had gone too far. Newman's reasoning was condemned as casuistical, and his covert allegiance to Rome suspected. Four Oxford dons, including the future Archbishop of Canterbury, Tait (see no. 65), agreed to write a condemnatory letter to the press, which Tait drafted, and then the university, in the form of almost all the heads of colleges and the Vice-Chancellor, declared their opposition to Newman's *Tract*. Newman defended himself by clarifying parts of the argument in a *Letter to Dr Jelf* (no. 63), and prepared a revised edition of the Tract. Archbishop Howley (see no. 29) then put pressure on Bishop Bagot of Oxford to induce Newman to discontinue the Tracts. Newman agreed to do so, and to write a public letter declaring his intention to comply with the request, and his lack of sympathy for the Roman Catholic Church.

The Fathers of the Birmingham Oratory

63 John Henry Newman, 'A Letter addressed to the Rev. R. W. Jelf D.D.' Oxford, 1841

Book, 21.5 × 14.3 (8½ × 5⅝)

Newman's explanation of *Tract XC* (no. 62) was published in a pamphlet on 15 March 1841, a few hours after the University's public censure of his *Tract*. In it he felt compelled to state beyond all doubt that the Roman Catholic Church was in error and thoroughly in need of reform (Ker, p. 220). He admitted 'even though I be right in principle, I may have advocated truth in a wrong way' (p. 5).

The Fathers of the Birmingham Oratory

64 Charles James Blomfield, 1786–1857, and Henry Edward Manning, 1808–92, with Sir John Gurney, 1768–1845

George Richmond

Pen and ink, 22.7 × 19 (9 × 7½)

PROVENANCE: Mrs John Richmond; E. Kersle; Sir Geoffrey Keynes, presented by him, 1960.

LITERATURE: Ormond, p. 41.

The drawing is inscribed by Richmond with the names of Gurney and Manning; the third figure is identified only as an unnamed Bishop of London and the location as Fulham Palace, official residence of the Bishop of London. Gurney, described here as 'baron', held the post of Baron of the Exchequer up to his death in 1845. Manning, described as Archdeacon, became Archdeacon of Chichester in 1840. All three men sat to Richmond for their portraits: this sketch presumably was the result of a sitting with at least one of them. The drawing must therefore date to between 1840 and 1845, and the Bishop must be Blomfield. Sir John Gurney sat to Richmond in 1844, Manning in 1845, therefore the period 1844–5 is the most probable date.

At this period Blomfield (see no. 30) was much concerned with the effect of Newman's *Tract XC* and the series of conversions which took place prior to Newman's, and Manning (see no. 114) had spoken against *Tract XC*. Richmond's sketch gives a vivid impression of a pair of Anglican clerics engaged in close discussion.

National Portrait Gallery (NPG 4166)

65 Archibald Campbell Tait 1811–82

James Sant

Oil on canvas, 132.1 × 107.3 (52 × 42½)

PROVENANCE: By descent to Mrs E. H. Colville, by whom given to the Gallery, 1967.

Tait became a Fellow of Balliol in 1834 and was ordained in 1836, when the Oxford Movement was underway. His closest friends at Balliol, William George Ward and Frederick Oakeley, became enthusiastic Tractarians, but Tait stood apart from them and in 1841, when Newman's *Tract XC* was published anonymously, Tait, with three other dons, published a letter condemning it and calling on the author to identify himself.

Tait became headmaster of Rugby in 1842 following Arnold (see no. 21), and in 1856, Bishop of London. As Bishop he was a fervent evangelist and church builder. In 1868 he was made Archbishop of Canterbury.

National Portrait Gallery (NPG 4580)

66 The Martyrs' Memorial, Oxford

Engraving by W. Radclyffe after F. Mackenzie; published by J. H. Parker of Oxford, 1 November 1849

23.2 × 34.3 (9¼ × 13½)

The building of the memorial to the Protestant Martyrs burned in Oxford during Queen Mary's reign in 1555–6 – Archbishop Cranmer, and Bishops Ridley and Latimer – was a reaction to the hatred of the Reformation expressed in Richard Hurrell Froude's *Remains*, edited by Newman (no. 58), the first volume of which was published in 1838. The Lady Margaret Professor of Divinity, Dr Godfrey Faussett, preached a sermon against the 'Revival of Popery' as evidenced in the *Remains* from Newman's pulpit in the University Church; this was published on 20 May 1838, and Newman wrote a pamphlet in reply.

Newman's opponents began a subscription for a memorial to the Oxford Martyrs, to which prominent churchmen including Archbishop Howley (see no. 29) subscribed; Newman, Keble and Pusey refused to subscribe (Pusey reluctantly). A cross was initially proposed, to which the Evangelicals objected, preferring a church; Archbishop

66

Howley consequently thought a church less contentious. In 1840 however, the subscribers agreed to have a cross, and also to add a commemorative aisle to the nearby church of St Mary Magdalen.

After a competition, the cross was designed by Sir George Gilbert Scott (1811–78), and built in 1841–3. It was to be based on the Eleanor Cross at Waltham but bigger. The details of Scott's design were very closely based on medieval originals of the late thirteenth and early fourteenth centuries, ironically demonstrating the spread of the antiquarian attitude towards Gothic architecture espoused by Pugin, despite the anti-Tractarian spirit in which the memorial was commissioned.

Lent by Jane and Clive Wainwright

67 Edward Bouverie Pusey 1800–82

Clara Pusey

Pen and watercolour on paper, 18.1 × 22.6 (7⅛ × 8⅞)

PROVENANCE: Peter Eaton; Theodore Hoffman, purchased from him, 1967.

LITERATURE: Ormond I, pp. 388, 563–4.

Pusey gave Newman strong support against the attacks on *Tract XC*; in 1842 he wrote a letter to Archbishop Howley (see no. 29) to try to stop the bishops' condemnation of the Tractarian movement and denied that the Tracts were responsible for the increasing numbers of conversions to Rome. In June 1843 he was condemned for heresy by the Vice-Chancellor of Oxford after preaching a sermon on the Eucharist, which was found to be contrary to Anglican doctrine, and Pusey was suspended from preaching to the university for two years. By this time Newman had retired to Littlemore (see no. 78) and Pusey was acknowledged as the *de facto* leader of the Oxford Movement (Keble kept to his country parish as much as possible); his position was confirmed by Newman's conversion in 1845.

This is one of a collection of over fifty drawings by Pusey's niece Clara, who with her brother and sister came to live with the Pusey household at Christ Church in 1855, and stayed there until her marriage in 1862. Many of the drawings were sent to her cousin Alice Herbert, with a running commentary.

National Portrait Gallery (NPG 4541)

68 John Henry Newman 1801–90

George Richmond, signed and dated 1844

Coloured chalks on paper, 41.3 × 33.6 (16¼ × 13¼)

PROVENANCE: George Richmond; purchased from his executors, 1896.

LITERATURE: Tristram; Ormond I, p. 339.

George Richmond was the first artist to whom Newman sat who was not a friend of the family, as Maria Giberne and Richard Westmacott were (see nos. 13, 72). The portrait was commissioned by Henry Wilberforce, Newman's great friend, whom he had tutored at Oriel. In 1838 Richmond painted a watercolour portrait of Henry Wilberforce's

67

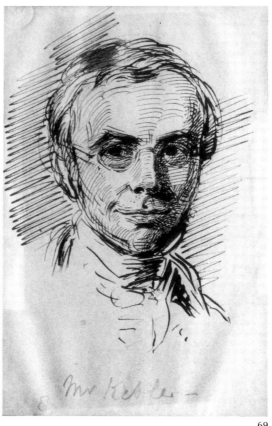

69

father, the reformer William Wilberforce (NPG 4997); more than ten years later, in 1844, Richmond's reputation as a society portraitist was well established. Many of his portraits were head-and-shoulders drawings in chalks, and Wilberforce told Newman 'it is not a finished painting that I want, but a crayon sketch on tinted paper like that he has taken of Manning'. (Letter of 5 July 1844, quoted by Tristram)

Newman had four sittings that July (Richmond had envisaged only two) and Wilberforce received a drawing in early August for his approval. Wilberforce commented on the drawing sent in 1844: 'I cannot say how much I like and value it. I almost expect to hear your voice at times, and the same is the feeling of others. The likeness is no doubt diminished by not having your glasses, which seem to me almost a necessary part of you – still I think Richmond has judged rightly here . . .'. (Letter, quoted by Tristram) The drawing cost £21, according to Richmond's sitters' book (photostat in National Portrait Gallery Archive). No. 68 is a study for the more finished drawing at Oriel College, Oxford (Lane Poole II, p. 101). A sitting with Richmond apparently recorded in Newman's diary on 21 June 1845 (quoted by Tristram) cannot relate to no. 68 and remains mysterious.

The Oriel portrait was engraved in 1856 by H. Maclean, who altered Newman's stock to an Oratorian collar.

Illustrated in colour on p. 33.

National Portrait Gallery (NPG 1065)

69 John Keble 1797–1866

George Richmond, c.1843

Pen and brown ink on paper, 16.5 × 10.5 (6½ × 4⅛)

PROVENANCE: 1st Lord Coleridge, by whom given to Keble College.

This small sketch appears to be a first idea for Richmond's portrait drawing of Keble (no. 48). The finished portrait appears more idealised than that shown here.

The Warden and Fellows of Keble College, Oxford

70 John Henry Newman

Sir William Ross, signed and dated 1845

Watercolour on paper, 53.3 × 38.1 (21 × 15)

No. 70 is a watercolour study for the miniature now at the Birmingham Oratory (no. 71).

Illustrated in colour on p. 36.

The Warden and Fellows of Keble College, Oxford

71 John Henry Newman

Sir William Charles Ross, c.1845

Miniature on ivory, 15.5 × 11.2 (6⅛ × 4⅜)

PROVENANCE: By descent to 1st Baron Aldenham; sold Christie's 2 May 1961 (193).

Sir William Ross, the leading miniaturist of the early years of Queen Victoria's reign, and miniature painter to the Queen herself, was given the commission to paint Newman by a wealthy parishioner at Littlemore, a Mr Crawley, a retired merchant. Ross stayed with Mr Crawley for two weekends in May and June 1845, and Newman sat to him for five mornings, thereby losing time for the writing of his *Essay on the Development of Christian Doctrine* (no. 73). (Tristram) He also sat to Ross in London in July, when he was sitting to Richmond (see no. 68). (ibid.) The watercolour sketch now at Keble College (no. 70) was presumably produced as a preliminary study for no. 71; it lacks the background of books in the miniature. No. 71 was engraved by R. Woodman.

Illustrated in colour on p. 38.

The Fathers of the Birmingham Oratory

72 John Henry Newman

Richard Westmacott, c.1841

Marble bust, h. 68.6 (27)

PROVENANCE: Collection of W. H. Mozley, 1891; given by the Mozley family to the Birmingham Oratory.

LITERATURE: Ormond I, p. 340.

The sculptor Richard Westmacott was a contemporary of Newman's at Ealing School. He was the son of Sir Richard Westmacott, one of the foremost sculptors of his day, and attended the Royal Academy Schools and took up sculpture

72

in compliance with his father's wishes; he would have preferred a legal career. Like his father, he was responsible for church monuments as well as portrait busts, and in 1839 executed a monument to Newman's mother for his church at Littlemore (see no. 76(ii)).

In July 1840 Newman was staying with Westmacott in London when 'he put me into plaister for his amusement, when he had nothing else to do . . . It was a very kind thing in him, but I was very much ashamed of having to consent'. (Letter to Maria Giberne, 16 September 1840, quoted by Tristram) The purpose of the plaster was evidently hidden from Newman, for J. B. Mozley wrote to his brother Thomas (Newman's brother-in-law) on 5 April 1841, 'Bloxam [Newman's curate] has let out the secret of J.H.N.'s bust to him the other day, quite unintentionally. It is finished now, so it is no matter whether he knows it or not'. (Quoted by Tristram) The finished marble bust was exhibited at the Royal Academy that year.

The Fathers of the Birmingham Oratory

73 John Henry Newman, 'Essay on the Development of Christian Doctrine' London, 1845

Book, 22.8 × 15.2 (9 × 6)

By the autumn of 1844 Newman was on the verge of conversion to the Roman Catholic Church, yet he felt unable to take the plunge since, as he explained in the *Apologia*, 'what inward test had I, that I should not change again, after that I had become a Catholic . . . So, at the end of 1844, I came to the resolution of writing an Essay on Doctrinal Development; and then, if, at the end of it, my convictions in favour of the Roman Church were not weaker, of taking the necessary steps for admission into her fold' (p. 748).

By the time the book was published, Newman had been received into the Roman Catholic Church: in the *Apologia* he explained, 'Before I got to the end, I resolved to be received, and the book remains in the state in which it was then, unfinished'. The *Essay* was a personal exploration and continues some of the themes which had preoccupied Newman as early as 1833 in *The Arians of the Fourth Century* (no. 24) and which animated the Tracts, including *Tract XC* (no. 62). Newman argued that the body of doctrines of the Christian faith is handed down through the church, rather than found through individual study of the Bible, as in the Protestant tradition; and that the church which is the recipient of these doctrines and therefore closest to the early Christian Church is not, as he had maintained in *Tract XC*, the Church of England, but the Church of Rome.

Newman's arguments concerning development of doctrine owed much to his study of the Early Church Fathers. He proposed that all valid developments were implicit in the activities and attitudes of the Early Church and became apparent and explicit during the course of history. He argued that although the external truths so revealed were in existence, it was impossible that they should be made completely apparent to the human mind in their entirety at any one point in history. This was quite different from the liberal notion 'That truth and falsehood in religion are but matters of opinion; that one doctrine is as good as another; that the Governor of the world does not intend that we should gain the truth; that there is no truth'.

The significance of Newman's reconciliation of religious doctrine to the processes of historical change (of which the nineteenth century was becoming so aware) went unrecognized when the *Essay* was published, but has since been acclaimed as one of his greatest intellectual achievements, one which enabled Newman – unlike so many of his contemporaries – to encounter Darwinism and other scientific developments with equanimity.

The Fathers of the Birmingham Oratory

74 Lives of English Saints, vol. I: 'The Cistercian Saints of England, St Stephen Harding' London, 1844

Book, 17.7 × 11.8 (7 × 4½)

LITERATURE: Belcher, p. 148; Ker, pp. 281–2.

While at Littlemore in the early 1840s Newman conceived a plan of editing a series of lives of 'Saints of the British Isles' a work which would be 'historical and devotional, but not controversial', with miracles 'treated as matters of fact, credible according to their evidence'. (Letter to J. W. Bowden of 3 April 1843, quoted by Ker, p. 281).

This first *Life*, written by J. D. Dalgairns (see no. 87), one of the community residing at Littlemore with Newman, was in proof when Pusey saw it. Pusey advised Newman against publication, on the grounds that the *Lives* would certainly be seen as pro-Catholic and highly provocative. Newman also consulted his friends James Hope-Scott and Gladstone, who both agreed with Pusey. Although Newman was reluctant to abandon the series and let down the young scholars from whom he had already commissioned work, he decided that the works already underway could be published individually, without his general editorship.

Sixteen volumes were issued in 1844–5, written by some authors who like Dalgairns, Faber (see no. 86) and Frederick Oakley, became converts, and others like Mark Pattison who did not. The first volume states in an 'advertisement' that it was 'printed with the view of forming one of a series of Lives of English Saints, according to a prospectus which appeared in the course of last autumn, but which has since, for private reasons, been superseded . . . other Lives, now partly written, will be published in a similar form by their respective authors on their own responsibility'.

Eleven of the volumes were published with frontispieces based on drawings by Pugin (now preserved in the Birmingham Oratory). The drawing for the frontispiece of this first volume showing St Stephen writing, with a cathedral in the background, and signed with Pugin's monogram, was included in an undated letter from Pugin to Dalgairns: Pugin wrote that it 'will I hope meet Mr Newmans [*sic*] wishes'.

The British Library Board (1370 bl/1 [1])

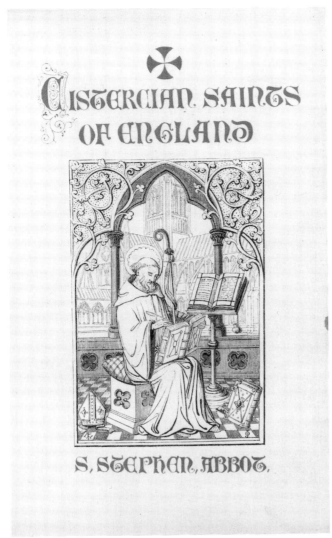

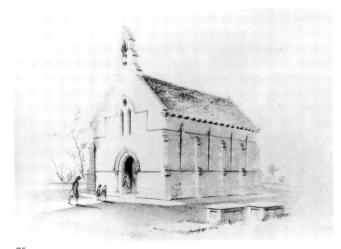

74

75

75 Church of St Mary and St Nicholas, Littlemore: Exterior

(i) Photograph of an engraving of Littlemore Church as first built in 1835

(ii) Photograph of Littlemore Church, c.1875

LITERATURE: James Patrick, 'Newman, Pugin and Gothic', *Victorian Studies* 24 (2), 1981, pp. 185–208.

As Littlemore Parish had no church, the Fellows of Oriel agreed in 1835 to support the building of a church there. The Church Building Society gave a grant, and there were other subscriptions. Building work began on 15 July 1835, and Newman's mother laid the first stone (see no. 76). The church was consecrated on 22 September 1836.

The church was built in the Gothic style, apparently initially based on a sketch drawn by Thomas Mozley (see no. 22) of the church at Moreton Pinckney, where he was Rector; the architect was Henry Underwood of Oxford.

In the context both of the religious views espoused by the Oxford Movement and of the revival of Gothic architecture urged by the Societies of both Oxford and Cambridge, founded in 1839 (see nos. 45, 47), the style and, even more so, the furnishings of Littlemore Church, were seen as highly significant and attracted considerable attention. Stained glass windows designed by Thomas Willement and paid for by Willement and J. R. Bloxam, Newman's curate, were added in 1839 (Bloxam papers I, p. 187); a design for a window in watercolour survives, signed by Willement and dated 11 October 1839 (ibid. I, p. 188). Bloxam, who had become curate in succession to Isaac Williams, and was a member of the Oxford Society for Promoting Gothic Architecture, went about furnishing the Church with great enthusiasm: parchments painted with a pelican, a fish and symbol of the Trinity were placed on the cornices, and in 1840 an altar cloth made by Newman's sisters was added. Two gilt wooden candlesticks were placed on the altar and two on the floor; the altar candlesticks were copied from ones at Magdalen College; the other pair were old ones sent from Oxford by the architect, J. C. Buckler and regilded (Bloxam papers I, p. 186). Bloxam also commissioned from J. C. Buckler two altar chairs after one at Winchester Cathedral, but at this Newman intervened, and they were removed. (Patrick, p. 189)

Littlemore Church and the manner of its furnishings inspired much comment from both enthusiasts and opponents, and Newman was clearly anxious to avoid controversy. Frederic Rogers, a Tractarian supporter (see no. 121) called the church 'one of the most perfect for its size that I ever saw' (letter quoted by Patrick, p. 191) and Mozley thought it influenced Pugin's design of St James, Reading (Patrick, p. 190). The Camden Society was much in favour, citing it as the first example 'of the Catholic feeling of a Church' with its emphasis on the altar rather than the pulpit. (James White, *The Cambridge Movement*, Cambridge 1962, p. 15) On the other hand, the Chaplain of All Souls, Oxford, the Reverend Peter Maurice described in his book of 1837, *Popery of Oxford Confronted, Disavowed & Repudiated*, how he 'felt an indescribable horror stealing over me' as he saw the altar with a stone cross and the stained glass.

76 Church of St Margaret and St Nicholas, Littlemore: Interior

(i) Copyprint after a photograph of the interior looking East (1904)

(ii) Copyprint after a photograph of the memorial to Mrs Newman by Richard Westmacott, 1836 (1904)

In the view of the interior the chancel and stained glass are clearly visible; on the left is Westmacott's memorial.

Richard Westmacott the younger, the sculptor and schoolfriend of Newman (see no. 72) was the obvious choice to design the memorial to Newman's mother Jemima. The monument shows an angel with a draped figure holding a ground plan of the church and gazing at a volume with a cross, presumably intended to represent the soul of Mrs Newman who laid the church's foundation stone, but did not live to see its completion, as the inscription on the memorial reveals. The angel appears to be pointing to the outline in low relief of Littlemore Church behind a grid of scaffolding. The bellcote seen in the engraving of the church as originally built (no. 75(i)) is clearly visible.

77 The 'Newmania'

Photograph of a coloured engraving in the Bloxam papers (I, p. 188), Magdalen College, Oxford

This engraving is based on the designs for the stained glass windows by Thomas Willement (see nos. 39, 75) added to Littlemore Church in 1840 and is preserved in the papers of Newman's curate at Littlemore, J. R. Bloxam. The engraving belongs to the period of caricatures of Newman and his followers (see nos. 55, 56) and punning on Newman's name (the cottages at Littlemore were called 'Newmanooth' after the Catholic Seminary of Maynooth in Ireland). The inclusion of stained glass windows in the church similarly gave rise to suspicions of Newman's interest in Roman Catholicism.

Bloxam explained no. 77 in a letter to Dr Macray of 22 January 1885 (R. D. Middleton, *Newman and Bloxam: An Oxford Friendship*, Oxford, 1947, p. 48): 'I have another stupid skit with *Newmania* underneath it. About 1839 when Curate of Littlemore, I put in three east windows, taking windows from a church in Bedfordshire as my model, but with different figures. The perpetrator of the joke took the top of, not one of the Littlemore windows, but of the Bedfordshire, and sent it about painted with *Newmania* underneath'.

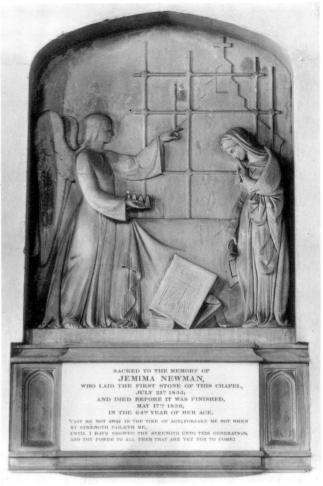

76

78

78 Littlemore Cottages

Copyprint after a photograph (1904)

In the summer of 1840 Newman bought land at Littlemore, and in February 1842 he moved from his rooms at Oxford to Littlemore, where, he explained to Maria Giberne, he was 'trying to set up a half college, half monastery'. Newman had an L-shaped block of six cottages and a stable; the stable was converted into a library. The press reported he was setting up an Anglo-Catholic monastery, and Bishop Bagot of Oxford called him to account: Newman replied that he intended nothing more than to continue with his scholarly work combined with the pastoral work needed at Littlemore; he would have his curate living there, and possibly a schoolmaster, together with men studying for ordination and helping in his pastoral work. The 'cloisters' of the newspaper report were nothing more than a shed.

A year later the cottages were all full and Newman was thinking of dividing them in two to provide more accommodation for men such as J. B. Dalgairns (see no. 87) and Ambrose St John (see no. 134). He described the routine in a letter to Maria Giberne: 'We have one joint-meal . . . during the day, at 5pm, which four days in the week consists of meat, generally cold. We break fast . . . not before noon . . . but separately and standing. We keep silence till 2 or 3pm according as it is winter or summer, and resume it at 8 or 9. We begin service at 6am – in Advent we begin at 3'.

Father Dominic Barberi who received Newman into the Catholic Church at Littlemore in 1845 (see no. 79) commented on the sparseness of the accommodation: 'nothing to be seen but poverty and simplicity – bare walls, floor composed of a few rough bricks without a carpet, a straw bed, one or two chairs, and a few books; this composed the whole furniture'. (Quoted by Martin, p. 70)

Newman left Littlemore for Old Oscott (Maryvale) on 22 February 1846, kissing 'my bed, and mantel piece, and other parts of the house'; he did not return until 1868.

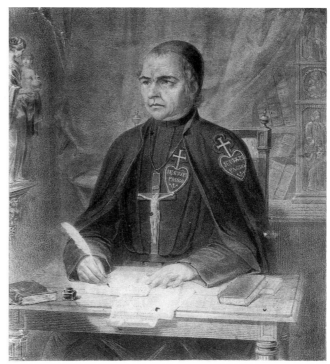

79

79 Father Dominic Barberi d.1849

Lithograph, 37.2 × 29.8 ($14\frac{1}{2} \times 11\frac{3}{4}$)

Father Dominic Barberi, an Italian priest of the Passionist Congregation, was travelling in England in 1845. He had already visited Littlemore once, and was asked by J. B. Dalgairns (see no. 87), whom he had already received into the Catholic church along with Ambrose St John (see no. 134), to visit Littlemore again. Newman, in a letter to F. W. Faber (see no. 86) wrote, 'I am this night expecting Father Dominic the Passionist, whom I shall ask to admit me into the One True Fold. This letter will not go until it is over'. (Martin, p. 73) Father Dominic arrived at Littlemore on 8 October in a rainstorm and recorded: 'The door opened – and what a spectacle it was for me to hear his confession and admit him into the bosom of the Catholic Church'. (Martin, p. 74)

The Fathers of the Birmingham Oratory

IV Newman and Rome 1845–79

Newman was ordained as a Catholic priest in Rome in 1847 with relatively little delay. He took up the suggestion that he should found the first English Oratorian order (the order of lay priests founded by St Philip Neri in Counter-Reformation Italy), and in 1848 Newman and a small band of followers set up the Oratory at Old Oscott, renamed Maryvale. In 1849 they moved to a converted gin distillery in Birmingham, while a second group of Oratorians established themselves in London under F. W. Faber (see no. 86).

In September 1850 Nicholas Wiseman was created the first English Cardinal since the Reformation as well as Archbishop of Westminster, and thirteen English Catholic bishoprics were also founded. To the Protestant English this represented 'Papal Aggression'. There was uproar and the Oratorians in Birmingham and London were besieged by hostile crowds. The foreign power of the Pope and Roman Catholicism seemed to be once more threatening the English state, as had happened in the days of the Armada and Guy Fawkes's plot. This feeling of crisis was exacerbated by the continued stream of conversions to Catholicism by eminent Anglicans. Gladstone had described Newman's conversion as the greatest crisis of the English Church since the Reformation; Newman was followed by others, notably Henry Manning, later Cardinal Manning, in 1851 (see no. 114). Newman's lectures, 'On the present position of Anglicans', were seen as a further instance of treachery. In 1851, at the height of the controversy, he was successfully sued for libelling a highly disreputable defrocked Catholic priest, Giacinto Achilli, who had been sent on a lecture tour of England by the anti-Catholic Anglicans in order to smear the Catholic Church. Unfortunately for Newman, the evidence which would have formed a successful defence arrived too late, and Newman was fined £100 plus £14,000 costs; a fund was established to cover this.

In 1852, with the Birmingham Oratory established in Edgbaston, where it remains, Newman moved temporarily to Dublin, in order to found a Catholic University; he was Rector from 1854 until 1858. There he gave the lectures which were published as *The Idea of a University* (no. 106), and in which he argued for universities as teachers of knowledge, rather than providers of practical training, and for a view of knowledge of which theology was an inseparable part. The foundation of the University was not a complete success. The divergence of the Birmingham and London Oratories caused some bitterness between the two communities, and having entirely abandoned Oxford Anglicanism and his old way of life, Newman found that he was still something of an object of suspicion to Catholics,

particularly those of the Ultramontane persuasion, who, ironically, regarded him as a dangerous liberal. In 1862 Charles Kingsley, a Christian Socialist (probably better known today as the author of *The Water Babies*), published a stinging attack on Newman in a book review which Newman could not let go unanswered. His reply took the form of the famous autobiographical *Apologia Pro Vita Sua* (no. 120) of 1864, in which he recounted in vivid, lucid prose his life as an Anglican until his conversion.

In 1870 the Vatican published the decrees which asserted the infallibility of papal authority, amid considerable controversy among Catholics; Newman was doubtful of the wisdom of this move. In England it was seen as a further sign of the danger posed to the state by Catholics; Gladstone wrote a pamphlet questioning the loyalty of English Catholics, and Newman replied in 1875 in *A Letter Addressed to His Grace the Duke of Norfolk* (no. 131). The mood of the country had changed since the panic of the 1840s and 1850s and Newman's honest conduct, clear-sighted arguments and brilliant prose and poetry (his poem *The Dream of Gerontius* [see nos. 171, 172] was published in 1865) had won him admiration and affection. The way was paved for his elevation to Cardinal in 1879.

80 Panorama of Rome in the time of Charles III

Engraving, 262.3 × 102.9 (103¾ × 40½)

According to the inscription on the brass plate of the frame, this panorama of Rome was given to Newman by J. R. Bloxam, who had been his curate at Littlemore Church (see no. 75).

The Fathers of the Birmingham Oratory

81 John Henry Newman and Ambrose St John at Rome

Maria Giberne, *c*.1846–7

Oil on canvas, 49.8 × 67 (19⅝ × 26⅜)

Newman and his fellow convert (see no. 134) are depicted in study at Rome. They arrived there in 1846, and were admitted to the priesthood in 1847; as a theologian of eminence Newman followed no formal course of instruction, and was made a priest after a relatively brief period. As Newman reads, a ray of divine light strikes him, while the Virgin appears in the background, in the image familiar from the 'Miraculous medals' of the period. The Virgin had appeared to St Catherine Labouret in 1830, with graces to bestow on the pious, visible here as long and short rays of

80

82

light emanating from her hands: the vision was commemorated on medals subsequently struck, and French Catholics praying for Newman's conversion gave him one (information kindly supplied by the Very Reverend Gregory Winterton).

Maria Giberne, the artist and family friend of Newman, herself a convert to Catholicism at this date, followed Newman to Rome, and later became a nun (see no. 84).

Illustrated in colour on p. 36.

The Fathers of the Birmingham Oratory

82 Pope Pius IX 1792–1878

Lorenzo Bartolini, signed and dated 1847

Marble relief, h. 25.4 (10⅛)

Newman was summoned to see Pope Pius IX with Ambrose St John in November 1846 during his stay in Rome at the College of Propaganda; as he bent to kiss the Pope's foot he knocked his head against the pontiff's knee, but otherwise the interview went well.

It was Pius IX who instituted the re-establishment in England of Catholic bishoprics in 1850, the act of 'Papal Aggression' which provoked political and ecclesiastical turmoil and tremendous hostility to English Catholics (see no. 96). Elected Pope in 1846, Pius IX founded numerous dioceses in Europe and in North and South America, and re-established the Catholic hierarchy in the Netherlands as well as England.

The Trustees of the London Oratory

83 John Henry Newman

Maria Giberne, *c.*1846–7

Oil on canvas, 75.5 × 62.9 (29¾ × 24¾)

Maria Giberne had tried in 1842, apparently without success, to persuade Newman to sit to her for a portrait, which would stand in place of the caricatures of him then

circulating (see no. 54). This portrait, showing Newman in his Oratorian collar and cassock, appears to date from the period Newman spent in Rome between 1846 and 1847, where Maria Giberne painted him with Ambrose St John (no. 81), although he is depicted without the characteristic spectacles. It does not, however, seem to be the portrait on which the lithograph by Vinter is based (no. 85), as Newman is here wearing a cassock, rather than an ordinary coat, and is not wearing his spectacles.

Illustrated in colour on p. 38.

The Fathers of the Birmingham Oratory

84

84 Maria Giberne 1802–85

Self-portrait, after 1863

Watercolour on paper, 15.4 × 12.5 ($6\frac{1}{16} \times 4\frac{15}{16}$)

Maria Giberne, who had converted to Roman Catholicism following Newman's conversion in 1845, later became a nun: she joined the Visitation Order at Autun in France in 1863. This self-portrait in nun's robes must therefore date from the period between 1863 and her death in 1885. No. 84 still hangs in Newman's room at the Oratory.

The Fathers of the Birmingham Oratory

85 John Henry Newman

J. A. Vinter after Maria Giberne, 1850

Lithograph, 21.3 × 16.6 ($8\frac{3}{8} \times 6\frac{9}{16}$), published by Lander Powell & Co of New Street Birmingham, 12 October 1850

This lithograph portrait of Newman records the signature of Maria Giberne, and shows Newman wearing ordinary clothes, rather than Oratorian dress: this suggests that the original drawing might have predated Newman's conversion, and could even have been made as a result of Maria Giberne's plea to Newman in 1842 to be allowed to take his portrait. The style of the portrait also perhaps has more in common with Maria Giberne's earlier drawings such as nos. 11 and 22 than with her oil portraits of this period, such as no. 81.

National Portrait Gallery Archive

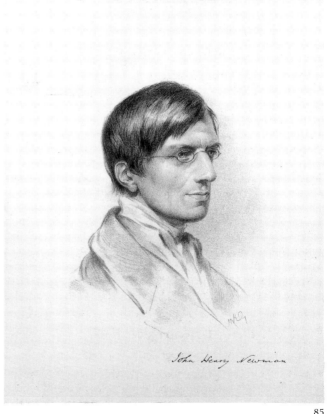

John Henry Newman

85

86 Frederick William Faber 1814–63

Modern copyprint after a daguerreotype at the London Oratory

Faber's family, like Newman's mother, was of Huguenot origin, and Calvinist in religion. While an undergraduate at Oxford he was strongly influenced by Newman, and became an enthusiastic supporter of the Oxford Movement. Faber was ordained in 1839 and Wordsworth, with whom he had formed a friendship, thought his career in the Church a loss to English poetry. He visited Rome in 1843, and was finally received into the Catholic Church in November 1845. As 'Brother Wilfred', he became the leader of a religious community at Birmingham, supported by the Earl of Shrewsbury (see no. 38). He was ordained priest in 1847.

86

In 1848 Faber and his community of 'Wilfridians' joined Newman's Oratorian order, and in 1849 he established the London branch of the Oratory; in 1850 he was elected Superior. Faber, like Manning (see no. 114), was a convinced Ultramontane, and thought that English-born Catholics were insufficiently prominent; he recommended that they should adopt the Italian baroque style, much to the disgust of the devotees of Northern Gothic led by Pugin and Lord Shrewsbury (see nos. 37, 38). In 1855, after friction between the London and Birmingham Oratories had arisen, Newman discovered that the London Oratorians had applied to Rome without his knowledge for alteration to their rule in order to undertake the spiritual direction of nuns. Newman protested to Faber, and asked him to petition Rome to recognize the independence of the two houses. Newman feared Faber was trying to establish authority over Birmingham, while Faber believed the reverse: the rift which opened up resulted in the independent status of the two Oratories.

87 John Dobrée Dalgairns 1818–76

Modern copyprint after a photograph at the London Oratory

Dalgairns graduated from Exeter College, Oxford in 1839, and was a keen follower of Newman. He was one of the translators of the *Catena Aurea*, an early commentary on the Gospels, published with Newman's preface between 1841 and 1845, and contributed four biographies to the *Lives of the English Saints*, edited by Newman. He joined Newman's community at Littlemore, and was received into the Roman Catholic Church by Father Dominic Barberi (see no. 79) in September 1845, a month before Newman.

In 1846 Dalgairns was ordained in France and he joined Newman in Rome in 1847. Dalgairns joined the community at the London Oratory, after a brief period at Maryvale, but between 1853 and 1856 assisted at the Birmingham Oratory. He later became Superior of the London Oratory (1863–5).

88 John Henry Newman, 'Loss and Gain: The Story of a Convert' London, 1848

Book, 17.7 × 12.1 (7 × 4¾)

Newman wrote *Loss and Gain*, his first novel, during his free time while staying in Rome in 1846–7 and after receiving a copy of a novel called *From Oxford to Rome* by Elizabeth Harris, published in 1847, which he thought 'fanciful'; he wrote his novel to show converts could still write 'common sense prose as other men'. (Martin, p. 148) Newman's novel was published anonymously on his return to England and sold well, although some critics claimed Newman had 'descended to the level of Dickens'. Like other similar novels of the period (see no. 118), it was semi-autobiographical, and tells the story of Charles Reding, an Oxford undergraduate, who undergoes conversion to Roman Catholicism. Reding in many ways embodies Newman's idea of development, as expounded in his *Essay* of 1845 (see no. 73), for rather than reach religious truth by argument, he realizes that true understanding is attained gradually and intuitively.

The character of Charles Reding and his progress towards the Catholic church is contrasted with a number of other characters who are satirically shown to be diverted in their own truth-seeking by characteristically vividly-described distractions of a worldly nature: the Tractarian tutor Mr Vincent, who checks if it is a fasting day ('Then let us have a plain beefsteak and a saddle of mutton; no Portugal onions, Watkins, or currant-jelly; and some simple pudding, Charlotte pudding, Watkins, that will do'.); the fiancée of a Tractarian clergyman who wants to buy a book with 'some hints for improving the rectory windows' and the Tractarian vicar who wants to introduce surplices and gilt candlesticks into a parish of impoverished city-dwellers.

The controversy concerning the Gothic revivalists' espousal of a return to medieval ecclesiastical church ritual which was raging at just this period (see nos. 45, 47) is also strongly reflected in the book. At a dinner 'conversation turned on the revival of Gothic architecture': the Tractarian Bateman, echoing Pugin (see no. 37) and the extremist position of the Camden Society (see no. 47), declares 'if he had his will there should be no architecture in the English church but Gothic, and no music but Gregorian', while the hero Reding, showing Newman's ability to distance truth from history, argues 'all those adjuncts of worship, whether music or architecture were national; they were the mode in which religious feeling showed itself in particular times and places'. In another passage Campbell states, 'I am for tolerance. Give Gothic an ascendancy; be respectful towards classical' and says, 'The basilica is beautiful in its place. There are two things which Gothic cannot show – the linear

forces, of round polished columns, and the graceful dome, circling above one's head like the blue heaven itself'.

Pugin visited Newman in Rome in April 1847 while he was writing *Loss and Gain*, and it seems likely that the arguments about Gothic, classical and early Christian architecture in the novel at least touch on their conversations and indicate the way in which Newman's thinking about the Oratory he was to return to build was progressing (see no. 91).

The Fathers of the Birmingham Oratory

89 John Henry Newman ('A Sketch from the Oratory')

Engraving, 10 × 6.8 (3$\frac{15}{16}$ × 2$\frac{6}{8}$), published on the Feast of the Ascension, 1850, 'For Private circulation'

A caricature of Newman showing a likeness not dissimilar to that of Maria Giberne's oil portrait of the period about 1846–7 (no. 83), and recalling the Oxford caricatures of a few years earlier (see nos. 55, 56).

National Portrait Gallery Archive

90 The Alcester Street Oratory

(i) exterior (ii) interior

Copyprints after photographs at the Birmingham Oratory

The Alcester Street Oratory opened on 2 February 1849 in, as Newman described it, 'a gloomy gin distillery of which we have taken a lease'; one room was fitted up as a chapel. There were also sixteen bedrooms, three sitting rooms, a private chapel and a library.

The Oratory was extremely successful in attracting the local Catholic populace: people had to be turned away on Sundays, when a congregation of 600 could be expected; there was a catechism class of 100 children.

91 Drawing for a Proposed Oratory Church at Birmingham

Louis-Joseph Duc, 1853

LITERATURE: R. O'Donnell, 'Louis-Joseph Duc in Birmingham, A "Style Latin" Church for Cardinal Newman in 1851', *Gazette des Beaux-Arts*, VIe période, vol. XCVIII, 1981, pp. 37–44.

When Newman was in Rome between 1846 and 1847 he was already considering the question of the design of the Oratory which he was to found. Pugin (see no. 37) called on Newman in Rome on 26 April 1847 and 'poured contempt upon the very notion which I suggested to him of building a *Gothic* Oratory, because an Oratory is not a medieval idea': Pugin called the Oratory 'nothing else than a mechanical institute'. It was hardly surprising that relations between them deteriorated thereafter. In a letter of 7 April 1850 to Mary Holmes (Sugg, pp. 85–7), Newman summarized the basis of the differences between Pugin and himself, which had been brought to a head by a pamphlet by Pugin attacking an article in the *Rambler* by M. E. Hadfield. Here and elsewhere Newman criticized Pugin for his disregard of the functioning of the church, citing a 'Puginian church' in which no one

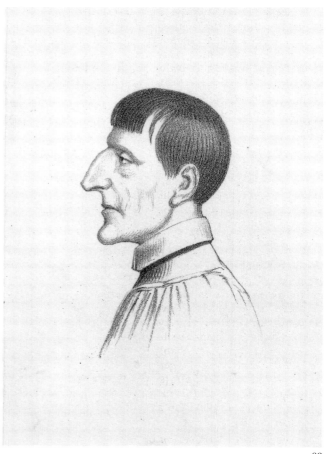

89

90

could see the elevation of the Host because of the presence of an eagle reading desk, a screen and thick arches and buttresses. Newman maintained that 'Gothic is on the whole a far *more* beautiful idea in architecture than Grecian – far more fruitful, elastic and ready', but that he found the dome and pillars of the early Christian basilica 'as beautiful, nay more so, than any thing in Gothic'.

In letters written in 1851, when Newman was contemplating the design of his Oratory church, he continued to meditate on the advantages of the basilica style, though he was now more specific: 'it is very important we should do something really good. The Spanish and Sicilian style seems to me one which must strike, whereas the Roman or most ancient basilica is somewhat like an omnibus. I am intensely of opinion that foreigners do such things infinitely better than we. Look at the public buildings of London and Paris'. (Letter of 5 May 1851 quoted by O'Donnell)

Nothing is known of how Newman came to commission the French architect Louis-Joseph Duc to design an imposing church with a nave 115 feet long, a dome and apse all in polychromed brick, in what the French called the 'style Lombard' or 'style Latin'; Newman's papers from this period do not survive in their entirety, so the information concerning this commission appears to be lost. Newman in fact did not take up the plans, probably for lack of funds, and went on to commission John Hungerford Pollen who had built the University Church in Dublin (see no. 105) in Byzantine style, to add a round arched aisle in 1858 to the simple utilitarian Oratory church and later an apse and transept in Norman style (see no. 92).

The Fathers of the Birmingham Oratory

92 The Birmingham Oratory at Hagley Road

(i) Exterior with the church to the right
(ii) Interior of the church
Copy photographs after originals at the Birmingham Oratory

The Oratory moved to new buildings at Edgbaston in 1852: the choice of Edgbaston was significant, as it indicated a move away from a mission to the city poor to sustaining the middle-classes of a much more prosperous area, and also provided a boarding school founded in 1859, attended among others by the 15th Duke of Norfolk (see no. 130), a Catholic counterpart to the Protestant public schools.

An appeal for money to build the church had been launched in 1850; plans to build a basilican church designed by Louis Joseph Duc (no. 91) were abandoned. The simple church built had a roof which came from an abandoned factory. In 1858, John Hungerford Pollen added an aisle, and later an apse and two transepts.

92

93 The Birmingham Oratory

Photograph after an illustration in *The Graphic*, 1890

The buildings of the school established in 1859 (see no. 92) and built by Henry Clutton in the early 1860s in Italian Renaissance style are clearly visible.

94 Photographs of extracts from the day books and ledgers of J. H. Hardman & Co. of Birmingham

(i) Metal day book: entry for 10 May 1851
(ii) Metal ledger

John Hardman was engaged in the family button-making business when he met Pugin; in 1838 he began making ecclesiastical metalwork in medieval style, according to Pugin's designs, recruiting silversmiths for the purpose. Hardman's expanded rapidly, not only supplying ecclesiastical furnishings, but also carrying out metalwork for the Houses of Parliament, on which Pugin worked.

Newman used Hardman & Co. as convenient suppliers of the basic equipment needed for setting up an oratory in a gin distillery. The ledger and day books (which survive in the collection of Birmingham City Library) record Newman's purchases in 1849 and 1850: an iron tabernacle, a railing for a sanctuary, a bread cutter, a processional cross, half-a-pound of best incense. Money must have been scarce, and the only precious metal item ordered is in the day book under 10 May 1851: 'A large silver paten gilt all

over', which cost £6.4s.6d; unfortunately it appears not to have survived.

Further items were ordered after the move to Hagley Road: brass candlesticks in 1859 and a portable chalice in 1862. By 1860 the account was no longer in Newman's name but in that of William Neville, who had joined the Oratory in 1851, and who eventually became Newman's secretary. Presumably Newman, tired and ill, was glad to be relieved of such items of basic administration.

95 John Henry Newman, 'Lectures on Certain Difficulties felt by Anglicans in submitting to the Catholic Church' London, 1850

Book, 23.2 × 15.6 (9⅛ × 6⅛)

In the years between 1845 and 1850, even before the re-establishment of a papal hierarchy in England in the autumn of 1850, the Catholic Church in England was seen to be strengthening its presence, while the Church of England appeared in increasing disarray. Pusey, Keble, Manning and other Tractarians were particularly dismayed by the Gorham case, which originated in a dispute over the doctrine of baptism between the Evangelical clergyman Gorham and the High Church Bishop of Exeter; this led in March 1850 to the Privy Council overturning the judgement of the ecclesiastical court that Gorham's beliefs were outside the Church of England. Arguments over the power of the state over the Church were renewed, and it was thought the Church of England might be permanently split between Evangelicals and supporters of the High Church.

Although some Anglicans converted to Catholicism as a result, notably Henry Wilberforce (see no. 108), others such as Keble (see nos. 124, 125) and Samuel Wilberforce (see nos. 109, 110) were more attracted to the idea of a Free Episcopal Church. Newman was asked by the London Oratory to give a series of Lenten lectures in 1850, to try to persuade waverers that the Church of England was shipwrecked, the idea of a Free Episcopal Church hopeless, and the only possible home for the members of the Oxford Movement in the Roman Catholic church. He compared the Church of England to a figment of the imagination: 'and, as in fairy tales, the magic castle vanishes when the spell is broken, and nothing is seen but the wild heath, the barren rocks, and the forlorn sheep-walls, so is it with us as regards the Church of England, when we look in amazement on what we thought so unearthly and find so commonplace or worthless'. Newman's combination of abuse – High Church Anglicans were told that John Bunyan and Methodists were preferable to them – and the retelling of his own personal road to conversion through the study of the Early Church Fathers was not well calculated to inspire waverers to join him; he confessed he had written 'intellectually against the grain'.

The Fathers of the Birmingham Oratory

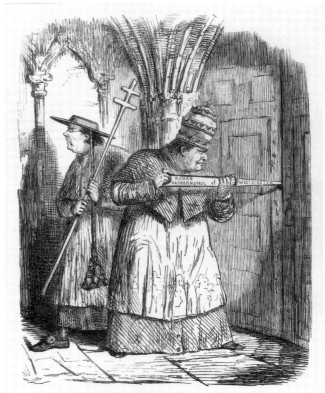

THE THIN END OF THE WEDGE.
DARING ATTEMPT TO BREAK INTO A CHURCH.

96

97

96(i) 'The Thin End of the Wedge – An Attempt to Break into a Church'

Copyprint after a cartoon published in *Punch*, 1850

In one of a series of cartoons published at the time of the 'Papal Aggression', Pope Pius IX (see no. 82) is depicted attempting to bore his way through the locked door of a church, using an instrument labelled 'Roman Archbishopric of Westminster'. In the background Cardinal Wiseman (see no. 99) lurks, keeping a look-out.

(ii) 'Mr Wiseboy and Mr Newboy'

Copyprint after a cartoon published in *Punch*, 1850

This caricature depicts Cardinal Wiseman ('Wiseboy') presenting Mr Punch with a papal bull while Newman ('Newboy') placates Mrs Punch's dog Toby (who appears not to remember him in his new guise). The caricature appears above a text mostly devoted to a monologue by Mr Punch in which he remarks of 'Wiseboy': 'The great object is to show that most of us in this country utterly scout his claim, and laugh at his red hat and red stockings, his ring and his crozier, and his Pontifical, whether he swears upon it to expurgate us or not'. He ends recalling 'the Armada went down and the island grew, and continues to grow in strength, and Truth and Freedom GOD SAVE THE QUEEN.'

97 Lord John Russell, 1st Earl Russell
1792–1878

Lowes Cato Dickinson, 1855/1867

Oil on canvas, 80.6 × 67.2 (31¾ × 24½)
PROVENANCE: E. Kersley, 1944; purchased 1978.
LITERATURE: Ormond I, p. 407.

Russell was Liberal Prime Minister for the second time during 1850, the year of 'Papal Aggression'. When he first became Prime Minister in 1846 the Irish problem was pressing, and Russell was anxious to establish better relations with the Papacy. It was first necessary to legislate to recognize the Pope's existence, as ancient acts of Parliament prevented the government from contact with the Pope. In 1847 Lord Minto was appointed ambassador to Rome, a necessity in view of Palmerston's foreign policy and the revolutionary church movement in Europe, and in 1848 a bill was passed legalizing the appointment. An amendment stated that the Pope's minister in London must not be an ecclesiastic.

In 1850 the Catholic hierarchy of bishoprics was restored and in February 1851 a bill was passed making the assumption of ecclesiastical titles by Romans Catholic priests illegal, but it was too late.

National Portrait Gallery (NPG 5222)

98 Edward Bouverie Pusey 1800–82

'Touchstone', 1850

Lithograph, 45.7 × 53.3 (18 × 21)

This cartoon showing Pusey 'falling between two stools' is a vivid representation of the position in which he found himself in 1850: under fire from Catholics and Anglicans alike. The Bishop of London, Blomfield (see no. 30), attacked him, and the Bishop of Oxford, Wilberforce (see no. 109), tried to prevent him preaching in the diocese. While some of those who converted to Catholicism in 1850 thought Pusey was weak-willed not to follow them, Pusey maintained it was his intention to die in the bosom of the Church of England; however he still refused to attack the Church of Rome.

National Portrait Gallery Archive

99 Cardinal Wiseman 1802–65

Henry Doyle

Chalk on paper, 55.2 × 41.9 (21¾ × 16½)

Wiseman was told in the spring of 1850 that he was to be made a cardinal and was summoned to Rome by Pope Pius IX (see no. 82) in August, to learn that the Pope intended to restore the Catholic hierarchy, thereby setting up a formal Church establishment in England, with bishoprics and archbishoprics. Wiseman was to be Archbishop of Westminster, as well as Cardinal. It was the use of Westminster in his title which Protestant England found particularly provocative, although in the other bishoprics care was taken to avoid clashes with Anglican titles, and indeed there was no Anglican Archbishop with Wiseman's title.

National Portrait Gallery (NPG 2074)

99

100 Newman Lecturing at the Corn Exchange, Birmingham

Maria Giberne, *c.*1851

Oil on canvas, 61 × 45.7 (23 × 18)

In June 1851 Newman began a series of weekly public lectures at the Corn Exchange in Birmingham published as *On the Present Position of Catholics in England*, in which he challenged the popular prejudice against Catholics. In the fifth lecture Newman attacked a former Catholic priest with a disreputable past, Giacinto Achilli, who had been sent on a lecture tour by the Protestant Evangelical Union to denounce Catholicism. As a result of his remarks, Newman was sued for libel. The case was tried in June 1852, and in January 1853. Newman was fined £100 and had to pay costs of £14,000 (see no. 101). Maria Giberne's picture is striking for its caricature-like depiction of Newman's audiences, who appear almost nightmarishly hostile.

The Fathers of the Birmingham Oratory

101 Ring set with a nugget of gold

Diameter 2.9 ($1\frac{3}{16}$)

PROVENANCE: Newman; London Oratory.

LITERATURE: Anna Somers Cocks, 'The Treasury', in ed. M. Napier and A. Laing, *The London Oratory Centenary 1884–1984*, no date, *c.*1984, pp. 150–1.

Engraved on one shoulder: *Rev. Adm. Doctori J. H. Newman* ['To the Reverend Admirable Doctor J. H. Newman'], and on the other: *Vero Fidei Defensori. Cath. California* ['a true defender of the Faith, from the Catholics of California'].

When in 1852 the verdict of the jury went against Newman in the Achilli libel trial (see no. 100), though he only had a small fine to pay, he was left with huge costs. A public subscription was set up on his behalf, with contributions from America as well as from Europe: so much was received that the remaining money paid for the university church at Dublin (see no. 105). This ring was a gift from the Catholics in California where gold-prospecting was in full swing.

The Trustees of the London Oratory

102 Crozier

Nickel silver crozier, the head enriched with ormolu mounts, Italian, *c.*1840

Length 201 (79)

Like no. 104, no. 102 and no. 103 were gifts made to Newman in 1854 when it was expected that he would be appointed a bishop. Nos. 102 and 103 were gifts of the London Oratory, but seem in the end never to have been presented to Newman and to have remained at the Oratory.

Illustrated in colour on p. 40.

The Trustees of the London Oratory

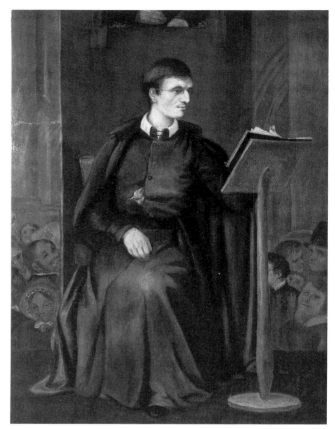

100

103 Mitre

Romanini of Rome, *c.*1855

Gold thread on white silk decorated with anemones and scrolling foliage, set with large tourmalines, garnets and amethysts
Height of mitre 40.7 (16), with lappets 89 (35)

The mitre is one of a set of three, similar, mitres made to be presented to Newman (see no. 102).

It is perhaps noteworthy that Newman's head was of above average diameter, since when one of the mitres is in use, it usually has to be padded out for the wearer.

Illustrated in colour on p. 40.

The Trustees of the London Oratory

104 Morse

J. H. Hardman and Co., 1854

Silver gilt enamelled in blue and set with amethysts; diameter 12 ($4\frac{3}{4}$)

PROVENANCE: Bequeathed by Newman to the Birmingham Oratory, 1878.

On the reverse the maker's mark of J. H. Hardman and Co., and the date letter for 1854.

This morse (the clasp traditionally used to fasten a bishop's cape) was presented to Newman by his friend James Hope-Scott of Abbotsford in 1854, when it was

expected that Newman would be made a bishop. In a note dated 12 July 1878 (typescript copy kept with the morse) Newman said that he had written in his last letter to the dying Hope-Scott on 2 August 1872 that he had been looking at the morse, made with jewels which had belonged to Hope-Scott's first wife, Charlotte Lockhart. Newman continued, 'The Jewels look as bright as ever and betoken the brightness of those whom we have lost sight of, and who are shining like stars in the heavens above'. He asked Hope-Scott what he would like done with the morse; Hope-Scott replied he might do what he could with it and Newman therefore recorded his intention to leave it 'as an heirloom to this Oratory'.

An account dated 4 September 1854 records a bill of £12.10s. for the morse, 'set with 24 Amythists (*sic*), which were sent by Mr Scott' (Hardman Archive metal daybook, p. 769 and metal ledger, vol. 4, p. 298, Birmingham City Library, information kindly supplied by Miss Glennys Wild of the City Museum and Art Gallery); a 'Gold Episcopal Ring, set with an Amythist (*sic*)' and with an inscription inside (ibid.) recorded at the same time must also have been intended as a gift for Newman from Hope-Scott.

James Hope-Scott (1812–73), a barrister, was responsible for giving Newman legal advice on more than one occasion, notably for the Achilli trial; he became a Roman Catholic at the same time as his friend Manning (see no. 114) in 1850. His second wife was the sister of the 15th Duke of Norfolk (see no. 130) and Hope-Scott was the Duke's guardian. He was also responsible for the affairs of the grandson of the 16th Earl of Shrewsbury (see no. 38).

Illustrated in colour on p. 40.

The Fathers of the Birmingham Oratory

105 The interior of the University Church of St Peter and St Paul, Dublin

Copyprint after an original photograph at the Birmingham Oratory
LITERATURE: *Victorian Church Art*, p. 39.

As Rector of the Catholic University of Dublin (1854–8) Newman was keen to see a university church built to symbolize 'the great principle of the University, the indissoluble union of philosophy with religion' (quoted by Ker, p. 433), as set out in his lectures (no. 106). The money left over from the fund established to pay for the costs of the

Achilli libel trial (see no. 100) was to pay for the church. Newman bought some land by St Stephen's Green near the University House and asked John Hungerford Pollen, whom he had appointed Professor of Fine Arts, to design the church in early Christian style. Newman was delighted with the result, especially the apse and wrote, 'to my taste, the church is the most beautiful one in the three Kingdoms'. (Ker, p. 446) The Church was opened on 1 May 1856, and Newman preached the first of his University sermons in it on the following Sunday.

The Fathers of the Birmingham Oratory

106 John Henry Newman, 'Discourses on the Scope and Nature of University Education. Addressed to the Catholics of Dublin' ('The Idea of a University') 1852

Book, 22.5 × 15 ($8\frac{7}{8} \times 5\frac{7}{8}$)

The Idea of a University was originally conceived as a series of lectures, five of which Newman delivered in 1852 at Dublin, where he had gone to found a Catholic University, and which were then published later in the year. The first collected edition was published in 1852 as *Discourses on the Scope and Nature of University Education*; and the title was changed to *The Idea of a University Defined and Illustrated* when the 1873 edition was published.

The lectures set out to define the role of a university, and in the preface Newman stated that a university 'is a place of *teaching* universal *knowledge*'. Newman believed that a university should not simply be a research centre, as some were arguing universities should be in the context of contemporary debates on university reform (a commission in 1850 had found Oxford lacking in both the quality and quantity of published research): that was a role for academies. Nor was it to be simply a seminary for priests: if the purpose of a university were simply 'religious training', argued Newman, 'I do not see how it can be the seat of philosophy and science'. This was a potentially controversial statement, since Catholics were eager to see a university which would strengthen the position of their religion. He proposed that religious *training* had as little place in the university he envisaged as the practical training for any profession. He insisted 'the man who has learned to think and to reason and to compare and to discriminate and to analyse, who has refined his taste, and formed his judgement, and sharpened his mental vision, will be . . . placed in that state of intellect in which he can take up any one of the sciences or callings I have referred to or any other, with an ease, a grace, a versatility, and a success, to which another is a stranger'. In these words Newman formulated the classic argument for a higher education system in which students may choose to study subjects with no immediate practical application.

In the *Tamworth Reading Room* (no. 60), Newman deplored the setting up of knowledge as an end in itself. In his blueprint he distinguished the university he envisaged from the purely secular institutions of Tamworth and University College, (the latter of which he again satirized). While he admitted that knowledge *could* be an end in itself, he argued

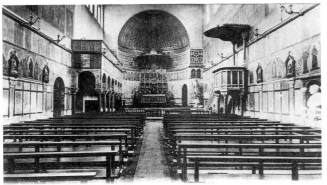

105

that 'the science of Religion' must also be included. The study of all branches of knowledge that would be undertaken at Newman's university could not be separated from theology nor theology from it, for any rigorous course of thought or pursuit of philosophical truth would lead inevitably and indissolubly towards it.

Newman wrote the lectures in difficult circumstances, in lodgings in a strange country, writing and re-writing (as he usually did) and dreading the public delivery. The forceful, balanced arguments and the beauty of Newman's prose make this one of his masterpieces: he himself described this work in 1852 as one of his 'two most perfect works artistically' (the other was *On the Present Position of Catholics*).

The Fathers of the Birmingham Oratory

DISCOURSES

ON

THE SCOPE AND NATURE

OF

UNIVERSITY EDUCATION.

ADDRESSED TO

THE CATHOLICS OF DUBLIN.

BY

JOHN HENRY NEWMAN, D.D.,

PRESIDENT OF THE CATHOLIC UNIVERSITY OF IRELAND,

AND PRIEST OF THE ORATORY OF ST. PHILIP NERI.

"ATTINGIT SAPIENTIA A FINE USQUE AD FINEM FORTITER, ET DISPONIT OMNIA SUAVITER".

DUBLIN:

JAMES DUFFY, 7 WELLINGTON QUAY,

PUBLISHER TO HIS GRACE THE CATHOLIC ARCHBISHOP OF DUBLIN.

1852.

106

107 John Henry Newman

Richard Doyle

Pen and black ink on paper, 6.9 × 5.7 ($2\frac{3}{4}$ × $2\frac{1}{4}$)
PROVENANCE: Purchased at the Doyle sale, 1886.

One of a number of small caricature sketches of prominent figures made by Doyle; a second sketch by the same artist is also known (see Iconography, Undated Portraits).

The Trustees of the British Museum (Department of Prints and Drawings – 1886–6–19–68)

108 Henry William Wilberforce 1807–73

Copyprint after an original carte-de-visite photograph in the National Portrait Gallery Archive.

Henry Wilberforce, the youngest son of the great reformer William Wilberforce, and brother of Robert, William and Samuel, was one of Newman's students at Oriel College between 1826 and 1830; his brother Robert was at this period a Fellow of Oriel. Newman later described him as his 'oldest friend'. Wilberforce subsequently studied law, but Newman persuaded him to abandon this for the Church and he eventually succeeded to the living of East Farleigh, previously held by his brother Robert. In 1834 he married Mary Sargent; one of her sisters was married to his brother Samuel, and another to Henry Manning (see no. 114). In September 1850 both Wilberforce and his wife became Roman Catholics, followed by Manning in 1851. Wilberforce's secession, just before the act of 'Papal Aggression' (see nos. 96, 99), helped to fuel the feeling of crisis within the English Church, and the anxiety that prominent church figures would continue to join the Catholic Church. From 1854 to 1863 Wilberforce owned and edited the newspaper *The Weekly Register* (originally *The Catholic Standard*).

109 Samuel Wilberforce 1805–73

Carlo Pellegrini ('Ape'), c.1869

Watercolour on paper, 30.5 × 18.1 (12 × $7\frac{1}{8}$)
PROVENANCE: Charles Newman; purchased from him, 1923.
LITERATURE: Ormond I, p. 505.

Samuel Wilberforce was the third son of William, and brother of Henry (see no. 108), Robert and William. He was a graduate of Oriel College, like his brothers, and was ordained in 1829. An energetic and ambitious man, in October 1845 he was appointed Bishop of Oxford. The following month Newman was received into the Roman Catholic Church; Wilberforce's sister-in-law and her husband followed him in 1846, his brothers Henry in 1850, Robert in 1854, William in 1863, and his daughter and son-in-law in 1868.

Wilberforce himself, nicknamed 'soapy Sam' in 1864, on account of his reputation for equivocation, was generally expected to follow his family into the Catholic Church. He steered a successful course as Bishop of Oxford, however, gaining Pusey's confidence, as well as being active in supporting the missionary bodies, church building and

107

108

educational provision. In 1869 he was made Bishop of Winchester, but was killed in a riding accident in 1873. Four days before his death he said in the House of Lords, 'I hate and abhor the attempt to Romanise the Church of England'. Newman commented on his death, 'There is something inexpressibly sad in the picture of a man going out on a beautiful Saturday, with a few friends, in a beautiful county, with everything calm, joyous and heavenly around him, and suddenly being carried off to the awful darkness of the other world'. (Quoted by Ker, p. 675)

The caricature by Pellegrini was published in *Vanity Fair* on 24 July 1869 as 'Statesman, No. 25. "Not a brawler"'.

National Portrait Gallery (NPG 1993)

110 Samuel Wilberforce 1805−73

'AT'

Copyprint from a negative in the National Portrait Gallery Archive

A graphic representation, published in *The Mask*, of Wilberforce walking a tightrope from Oxford, where he has rested his Bishop's mitre, towards Rome, which he is nearing with the aid of a balancing pole labelled 'Ritualism'.

110

111 John Henry Newman

Heath and Beau, 1861

Carte-de-visite photographs, (i–iii) 10.3 × 6.4 (4⅛ × 2½);
(iv) 9.5 × 6.4 (3¾ × 2½)

Newman was photographed by Heath and Beau in London in December 1861; he was visiting the house of the convert Henry Bowden, brother of J. W. Bowden with whom Newman had been close friends at Oxford. This appears to have been the first time that Newman was photographed: the fashion for cartes-de-visite, begun by the Royal Family, was establishing itself. This was the first of many sittings to photographers. Newman readily gave away the resulting cartes when asked; in 1867, for instance, a Vatican official, Monsignor Nardi, called on him in Birmingham; Newman recorded laconically, 'He wanted my photograph. I gave him two'. (Ker, p. 614)

These four photographs may all have resulted from the one sitting, although in (iv) Newman is robed differently, and stands against a stage-set studio background.

The Fathers of the Birmingham Oratory

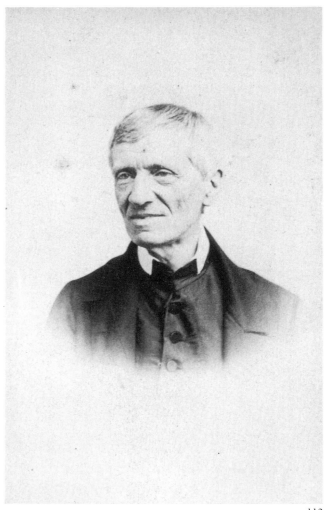

112

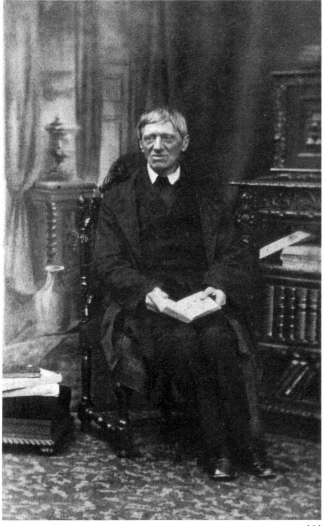

111

112 John Henry Newman

S. Bureau, 1863

Carte-de-visite photographs (i–ii), 10 × 6.1 (4 × 2⅜)

In the summer of 1863 Newman and William Neville (see no. 156(ii)) left England for Newman's first visit abroad since his trip to the Mediterranean thirty years earlier (see no. 26). At Ostend they saw Leopold I, King of the Belgians walk past, and he bowed to them; Newman wrote: 'I was surprised at his young appearance. The last time I saw him was at the Coronation of George the IV [*sic*], July 1821'. (Sugg, p. 145) They went on to Paris, where these photographs were taken.

The Fathers of the Birmingham Oratory

113 John Henry Newman

Mclean & Haes, 1864

Carte-de-visite photographs (i–ii), 10.5 × 6.2 ($4\frac{1}{8}$ × $2\frac{7}{16}$)

In his diary for 21 July 1864, Newman records sitting for the London photographers Mclean & Haes, who had their studio at 26 Haymarket.

The Fathers of the Birmingham Oratory

114 Henry Edward Manning 1808–92

Adolphus Wing

Albumen print, 27.9 × 21.6 (11 × $8\frac{1}{2}$)

Manning graduated from Oxford in 1830, and was elected a Fellow of Merton in 1832 and ordained in the same year. He became rector of Woollavington in Sussex, and in 1840 was made Archdeacon of Chichester (see no. 64). He was appointed select preacher at Oxford in 1842, and although sympathetic to the Oxford Movement, disliked *Tract XC* and distressed Newman by preaching an anti-papal sermon at St Mary's (Newman's old church) on Guy Fawkes Day in 1843.

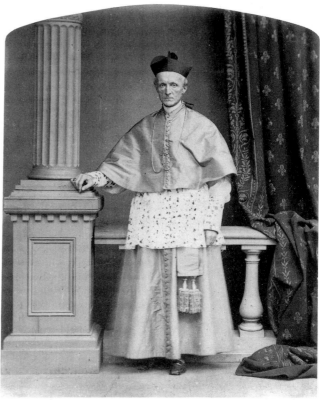

114

It was not until 1850, after a continental tour during which he had an audience with Pope Pius IX, that Manning decided his position was untenable, and he resigned as Archdeacon. In 1851 he became a Roman Catholic and was ordained. He spent some time in Rome, but in 1854 he returned to England, and, as Provost of the Chapter of Westminster, he led a community of secular priests on educational and mission work.

In 1864 his letter *On the Workings of the Holy Spirit in the Church of England*, addressed to Pusey, provoked Pusey's *Eirenicon*, which in turn prompted Newman's reply (see no. 120).

In 1865, following Cardinal Wiseman's death, Manning was created Cardinal, and continued his educational and pastoral work. He was a member of two royal commissions, on housing (1884–5), and on education (1886–7).

Manning was an Ultramontane Catholic, insisting priests wore Italian-style vestments and pronounced Latin with an Italian pronunciation; he was extremely popular with poor Catholics. To Manning, Newman was tinged with liberalism, still too much of an Oxford intellectual, and the *Apologia* was evidence of it. Newman and Manning took divergent views on papal infallibility as defined by the Vatican Council of 1870; Manning supported it; Newman, while accepting the doctrine, found the definition limiting. The two men represented different strands in the Catholic Church: their equal validity was recognized when Newman was also made a Cardinal in 1879.

National Portrait Gallery Archive

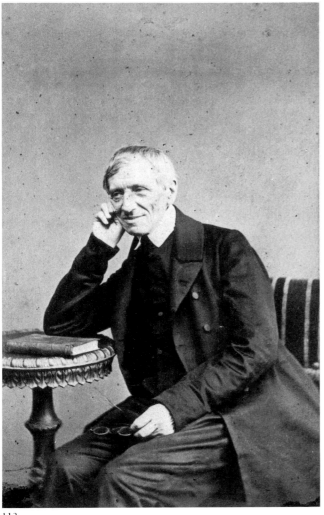

113

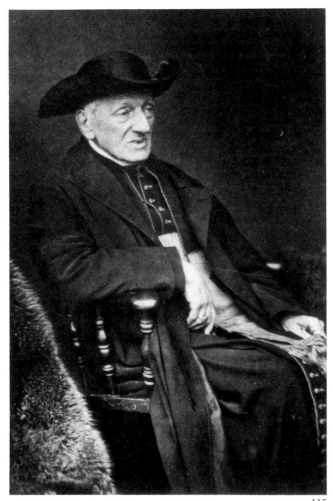

115

115 John Henry Newman

H. J. Whitlock

Carte-de-visite photograph, 12.1 × 7 (4¾ × 2¾)

Joseph Whitlock was the first professional photographer to work in Birmingham, setting up his studio at 120 New Street in 1842. His son Henry Joseph Whitlock took over the business, moving to 11 New Street in 1864 (C. E. J. Aston *et al.*, *Professional Photographers in Birmingham, 1842–1914*, Birmingham, 1987), where Newman was portrayed evidently on more than one occasion. (See also no. 139)

Owned by Mr Philip Anthony Fourdrinier Fenn

116 John Henry Newman

Thomas Woolner, signed and dated 1867

Marble bust, h. 68 (26¾)

LITERATURE: Lane Poole III, p. 286; Tristram.

Newman sat to Woolner at the suggestion of Mrs Thomas Coombe, wife of the superintendent of Oxford University Press, at whose marriage in 1840 he had officiated. She wrote

to him on 23 February 1865 (letter quoted by Tristram) and Newman replied on 1 March 1866: 'As to your proposal that I should sit to Mr Woolner, as you may suppose, at first it startled me – but it is too kind and too flattering to admit of my declining it.' (T. Woolner, *His Life in Letters*, p. 271) Subsequently, on 9 June 1866, Newman wrote to Woolner that he would begin sitting on 19 June (ibid., p. 272); interestingly, he promised not to forget to bring photographs of himself. The sittings took place in London, as Newman recorded in his diary. (Cited by Tristram)

Woolner and Newman remained on good terms, and Woolner considered taking another portrait of him after he became Cardinal. He wrote to the poet Coventry Patmore: 'I shall never forget how beautiful the dear old man looked once, when I went down to Birmingham to see him, in a rich silk gown that fell in the most graceful folds over his thin elegant figure'. (Cited by Tristram) Patmore himself wrote of Woolner's bust that it was 'By far the best likeness of Cardinal Newman' and that 'Woolner had so expressed the weight of Newman's intellect and character' that other busts of famous men he saw looked 'like vegetables in comparison with it'. Patmore may perhaps have been recalling the display of busts in Woolner's studio photographed *c*.1875 (see no. 117) in which a plaster of Newman is prominent. The original marble was exhibited at the Royal Academy in 1867; plasters are in the collections of the National Portrait Gallery and Trinity College, Cambridge.

The Warden and Fellows of Keble College, Oxford

117 Thomas Woolner 1825–92

Copyprint after a photograph by J. P. Mayall in the National Portrait Gallery Archive.

Woolner was the only sculptor member of the Pre-Raphaelite Brotherhood, founded in 1848; he also contributed poetry to the Pre-Raphaelite journal *The Germ*. In 1852 he emigrated to Australia but returned to England in 1854, where, the Brotherhood dispersed, he set up a successful practice as a portrait sculptor, especially noted for his busts.

The photograph shows him at work on his bust of Tennyson (see Ormond I, p. 452) of whom he was a particular friend, while on the left, in the centre of the photograph, partly concealed, can be seen his bust of Newman (no. 116).

118 James Anthony Froude 1818–94

Sir George Reid, 1881

Oil on canvas, 34.6 × 23.5 (13⅝ × 9¼)

PROVENANCE: Purchased 1974.

A younger brother of Hurrell Froude (see no. 57), he was an undergraduate at Oriel from 1835 to 1842, where his brother had been a Fellow, and in 1842 was elected a Fellow of Exeter College. He was strongly influenced by Newman, although not close to him, and visited Newman at Littlemore in the early 1840s. Newman commissioned him to write the 'Life of St Neot' in the series *The Lives of the Saints* (see no. 74), published in 1844.

Froude did not however follow his contemporaries to Rome, but was already reacting against it in the late 1840s. His novel, *The Nemesis of Faith* (1849), includes Newman as a character who rescues the hero from suicide. It caused controversy and on the day it was publicly burnt Froude resigned as a Fellow of Exeter. In 1849 he met Thomas Carlyle, and shortly afterwards, married to the sister of Charles Kingsley (see no. 119), he settled down to write historical books and articles, notably his twelve-volume *History of England* (1856–70), much admired by Kingsley.

In 1853 *Macmillan's Magazine* sent the seventh and eighth volumes of Froude's *History of England* to Charles Kingsley for review. Kingsley's enthusiastic review contained the notorious attack on Newman's truthfulness which led to the publication of the *Apologia* (see nos. 119 and 120).

National Portrait Gallery (NPG 4990)

119 Charles Kingsley 1819–75

Adriano Cecioni, *c*.1872

Watercolour, 30.5 × 18.1 (12 × 7⅛)

PROVENANCE: The Homeland Association since 1919, from whom purchased 1922.

LITERATURE: E. Harris & R. Ormond, *Vanity Fair*, exh. cat., 1976 (no. 49).

After graduating from Cambridge and ordination in 1842, Kingsley became closely associated with F. D. Maurice's Christian Socialist movement. Where the Oxford Movement was concerned with Anglican doctrine and the relationship between Church and State, the Christian Socialists had little interest in doctrine and supported the Chartist movement

119

117

which threatened the government in 1848. Kingsley published a number of tracts promoting Christian Socialism, as well as the novels *Yeast* (1848) and *Alton Locke* (1850). Kingsley's religious sympathies did not hinder his career, despite being banned from preaching in 1851; in 1859 he became one of Queen Victoria's Chaplains in Ordinary and in 1860 was appointed Professor of Modern History at Cambridge. In 1863 he published *The Water Babies*.

In January 1864 Kingsley wrote in a review of Froude's *History* in *Macmillan's Magazine* that 'Truth, for its own sake, had never been a virtue with the Roman Catholic clergy. Father Newman informs us that it need not and on the whole ought not to be'. There was an exchange of letters, and Kingsley made a public apology which Newman was advised was insufficient. Kingsley replied in a pamphlet called *What, then, does Dr Newman mean?* Newman's reply was his *Apologia Pro Vita Sua* (no. 120), and Kingsley, now in poor health, was silenced.

This drawing was published in *Vanity Fair* on 30 March 1872.

National Portrait Gallery (NPG 1939)

120 John Henry Newman, 'Apologia Pro Vita Sua' London, 1864

(i) Autograph manuscript, 21 × 16.5 (8¼ × 6½)

(ii) Book, 22.3 × 14 (8¾ × 5½)

Newman's famous autobiography of his life as an Anglican up till 1845, was written in response to Charles Kingsley's attack on him in *Macmillan's Magazine* in 1862 (see no. 119). Kingsley's attack implied that his life as an Anglican had been lived as a lie (indeed at the time there were rumours that Newman had become a Catholic some time before the date of his conversion) and prompted the *Apologia*. Newman had half attempted a 'history of his religious opinions' in his *Lectures on Certain Difficulties* (no. 95), made autobiographical jottings, and kept numerous letters. In his preface, Newman wrote, 'It is now more than twenty years that a vague impression to my disadvantage has rested on the popular mind, as if my conduct towards the Anglican Church, while I was a member of it, was inconsistent with Christian simplicity and uprightness'.

The honesty and directness of Newman's *Apologia* had an immediate impact on its readers, particularly on its Anglican audience, who were able to see that Newman, although now a Catholic, was still the same man, and that there was nothing sinister about his personality. Moreover, contrary to his disparaging references to the Anglican church in *Lectures on Certain Difficulties*, here he paid tribute to the positive influence on him of his Anglican contemporaries. at Oxford.

Newman was constantly interested in the way he still identified with his youthful self, despite the change in his external appearance, and this interest was mirrored by his capacity to view historical change dispassionately, reassured by his sense of the eternal. He was thus ideally suited to autobiography, and his easy, fluent prose was well fitted for its task.

Newman never wrote without constant revisions, as his manuscript shows; his diary records that on one day he worked on the manuscript 'for 22 hours running'. (Quoted by Ker, p. 545) The book was published in a series of weekly pamphlets, which caused Newman additional strain.

The Fathers of the Birmingham Oratory

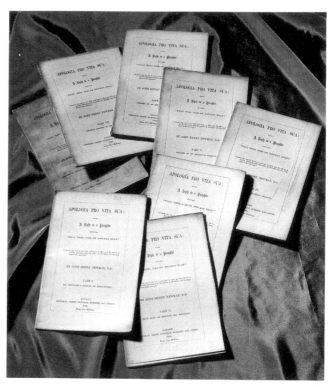

120

121 Frederic Rogers, 1st Baron Blachford 1811–89

Frederick Sargent

Pencil on paper, 16.5 × 11.4 (6½ × 4½)

PROVENANCE: B. & J. A. Tooth Ltd, from whom purchased 31 October 1951.

In 1832 Frederic Rogers graduated from Oriel College where he was taught by Hurrell Froude, and became a close friend of both Froude and Newman. He was elected a Fellow of the college in 1833, and also qualified as a barrister. A lifelong friend of Newman, he was an enthusiastic supporter of the Tractarian Movement.

In 1846 he and other churchmen started the weekly *Guardian* newspaper, but he also pursued a career in the

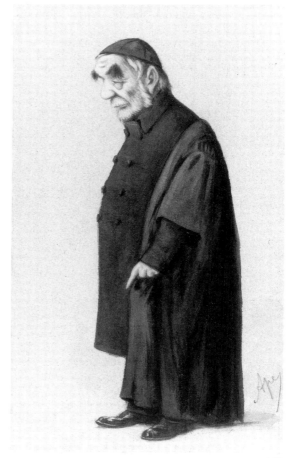

123

Civil Service and was permanent under secretary of state for the colonies (1860–71). In 1871 he was created Baron Blachford.

Rogers was in frequent correspondence with Newman, and influenced the content of the second edition of the *Apologia*, by persuading Newman to take out specific references to Kingsley.

National Portrait Gallery (NPG 3810)

122 John Henry Newman, 'Letter to the Rev. E. B. Pusey on his recent ''Eirenicon''' London, 1866

Book, 21.3 × 14 (8⅜ × 5½)

In 1865 Newman accepted Pusey's offer to send him his reply to a pamphlet of 1864 by Manning (see no. 114) entitled *The Workings of the Holy Spirit in the Church of England, a Letter to the Rev. E. B. Pusey*. Pusey's reply was called *The Church of England, a Portion of Christ's One Holy Catholic Church, and a Means of Restoring Visible Unity. An Eirenicon, in Letter to the Author of 'The Christian Year'*, and in it he attacked Catholic doctrine and particularly devotion to the Virgin and papal infallibility.

Newman decided that a reply was needed to demonstrate that Pusey's view of Catholicism, coloured by Manning's, was an extreme one. He wrote his *Letter to Pusey* in November and December 1865, when he was unwell; he decided to leave the discussion of infallibility for a second part, which he never undertook (but see no. 131). Newman argued, as he had in his *Essay on Development* (no. 73), that Catholic devotion to the Virgin follows the teachings of the Early Christian Fathers, but went on to say that because 'men are what they are', religious devotion in practice is liable to be subject to fanaticism, superstition and extravagances, from which English Catholics were protected by their 'natural good sense'. Newman's *Letter* was generally well received.

The Fathers of the Birmingham Oratory

123 Edward Bouverie Pusey 1800–82

Carlo Pellegrini ('Ape'), c.1875

Watercolour and body colour on blue-toned paper, 30.5 × 17.8 (12 × 7)

PROVENANCE: Thomas Bowles's *Vanity Fair* Sale, Christie's, 7 March 1912 (632); Thomas Cubitt; purchased from him, 1933.

LITERATURE: Ormond I, p. 388; E. Harris & R. Ormond, *Vanity Fair*, exh. cat., 1976 (no. 56).

Pusey continued to engage in controversy even in later life. His *Eirenicon*, a letter to Newman, was published in 1865, the year in which Newman, Keble and Pusey were reunited for the first time since 1845 (see no. 124). In it, he called for the Catholic Church to seek reunification with the Anglican Church, claiming as Newman had done in the heyday of the Oxford Movement, that there were no real doctrinal differences, and actually reprinting Newman's *Tract XC* (no. 62). Newman replied in *A letter to the Rev. E. B. Pusey on*

his recent '*Eirenicon*' (no. 122). Two more letters to Newman from Pusey were published in 1866 and 1869, and he wrote a third, but the Vatican Council of 1870 put an end to his hopes (see no. 131). He continued however in the 1870s to hope for a future reunion of the Church of England with the Eastern Orthodox Church.

The drawing was published in *Vanity Fair* on 2 January 1875, entitled 'High Church'.

National Portrait Gallery (NPG 2594)

124 John Keble 1792–1866

George Richmond, 1863

Coloured chalk and stump, with China white, on paper, 71.8 × 52.1 (28¼ × 20½)

PROVENANCE: Bequeathed by the artist, 1896.

LITERATURE: Ormond I, p. 247.

In 1863, the year of this drawing, Newman received the first letter from Keble he had had for seventeen years (Newman had in fact never replied to Keble's letter of 1846). Newman wrote back enthusiastically, 'Never have I doubted for one moment your affection for me – never have I been hurt at your silence'. (Ker, pp. 527–8)

In 1865, Newman visited Keble at his Vicarage at Hursley, near Southampton. Pusey was also there (although Newman had hoped to avoid the emotion of a double reunion): 'Keble was at the door, he did not know me, nor I him . . . it was the

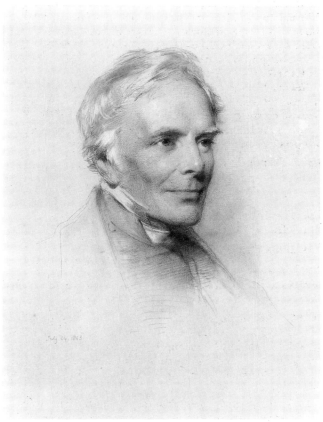

124

old face and manner, but the first effect and impression was different'. Newman noted 'he is as delightful as ever – and it *seemed* to me as if he felt a sympathy and intimacy with me which he did not find with Pusey'. (Ker, p. 578).

The drawing is listed in Richmond's account book (photostat copy, National Portrait Gallery Archive) on p. 77 for the year 1863 and is itself dated 24 July 1863. It was exhibited at the Royal Academy in 1864, and an engraving by W. Holl was published in 1864.

National Portrait Gallery (NPG 1043)

125 John Keble 1792–1866
R. H. Preston

Carte-de-visite photograph, 9.2 × 6 ($3\frac{5}{8}$ × $2\frac{3}{8}$)

This photograph appears to date from the period of Richmond's drawing (no. 124) and Keble's reunion with Newman and Pusey (see no. 124), 1863–5.

National Portrait Gallery Archive

126 Gerard Manley Hopkins 1844–89
Anne Eleanor Hopkins, signed and dated 1859

Watercolour on paper, 21.6 × 17.8 ($8\frac{1}{2}$ × 7)

PROVENANCE: By descent to Edward Manley Hopkins, by whom given, 1962.

The poet Gerard Manley Hopkins, author of *The Wreck of the Deutschland*, was strongly influenced by Pusey while at Oxford University, but did not remain an Anglican. He was received into the Roman Catholic Church by Newman at the Birmingham Oratory in 1866, when still an undergraduate, after first visiting Newman to consult with him on his course of action. After taking a first class degree, Hopkins joined the staff of the Oratory School for a short period before deciding to become a Jesuit. Newman wrote to him, 'I think it is the very thing for you. You are quite out, in thinking that when I offered you a 'home' here I dreamed of your having a vocation for us. This I clearly saw you had *not*, from the moment you came to us'. (Ker, pp. 624–5)

National Portrait Gallery (NPG 4264)

127 John Henry Newman
Sir Leslie Ward ('Spy'), c.1877

Watercolour and gouache on blue paper, 30.5 × 17.8 (12 × 7)

The magazine *Vanity Fair* published a cartoon of Newman by 'Spy' (Sir Leslie Ward) in its issue of 20 January 1877, for which no. 127 is the original study. Sir Leslie Ward considered that 'the most successful of my caricatures have been without exception those which were made without the knowledge of the persons portrayed'. (*Forty Years of 'Spy'*, L. Ward, London, 1915, p. 131) Ward recounts in his autobiography (ibid., pp. 132–3) how he had bought a ticket to Birmingham from Euston station in preparation for 'stalking' Newman 'when suddenly I caught sight of his Eminence on the platform. Here was an opportunity not be be missed! I saw him go into the buffet and followed him. He sat down at a small table and ordered soup. I took a seat opposite and ordered food also, studying him closely while he partook of it'. Ward attempted to observe Newman again in Birmingham, but in order to avoid a formal meeting had to flee without further sight of him.

The drawing remains in the type of mount usually used by the owner of *Vanity Fair*, Thomas Gibson Bowles, for his personal collection of original drawings for the periodical.

Illustrated in colour on p. 34.

The Fathers of the Birmingham Oratory

128 John Henry Newman
William Thomas Roden

Oil on canvas, 131 × 104 (51 × $40\frac{3}{4}$)

PROVENANCE: Presented to the College by Lord Halifax, about 1921.

LITERATURE: Lane Poole III, p. 286; Tristram.

Roden's portrait was commissioned in order that a portrait of Newman would hang in a public institution in Birmingham. The idea was first mooted in 1866 and Newman refused, on the grounds that he had 'been of no use whatever to this great Town'. (Ker, p. 708) When the proposal was put to Newman again in 1867 by G. D. Boyle, rector of St Michael's, Handsworth, Newman finally relented, but repeated: 'I have done nothing for Birmingham. I have paid my rates as an honest man, but have no claim on the place for any sort of service done for it of any kind'. (Letter cited by

126

128

Tristram) He also disliked the idea of being 'put in a collection together with a set of liberal party men or town celebrities with whom I had nothing in common'. (Sugg, p. 201)

It was not until 1874 that arrangements were made for Newman to sit to W. T. Roden, a successful local portrait painter who began his career as an engraver. Afterwards, in a letter to Lord Blachford of 3 June 1874, Newman referred to the portrait as 'very successful as a work of art' (Tristram), a phrase which concealed the lack of confidence Newman and others felt in the picture as a convincing representation of him. According to a letter Newman wrote to Lord Blachford (10 March 1877; Sugg, p. 201) Roden intended it to represent Newman 'lamenting my Oxford position'.

No. 128 is presumably the painting exhibited at the Royal Academy in 1875, but its subsequent history until its acquisition by Keble College is unknown (according to Newman, Roden was unpaid, the portrait pawned and afterwards sent on a touring exhibition). The picture now hanging in the City Art Gallery, Birmingham, is a replica painted in 1879 by Roden after a subscription was raised. Another version is in a Manchester City Art Gallery.

The Warden and Fellows of Keble College Oxford

129 William Ewart Gladstone 1809–98

Carlo Pellegrini

Watercolour on paper, 30.2 × 17.8 (11⅞ × 7)

PROVENANCE: Sale of Thomas Bowles, Editor of *Vanity Fair*; given anonymously in 1923.

LITERATURE: E. Harris & R. Ormond, *Vanity Fair*, exh. cat., 1976 (no. 32).

Gladstone thought Newman's conversion to the Roman Catholic Church was the 'greatest disaster in the English Church since the Reformation'. The tide of conversions to Catholicism touched Gladstone's own family: his sister became a Catholic in 1842. Gladstone himself was constantly preoccupied with questions of religion and state: in 1845 he resigned from Peel's government over the question of government support for the Roman Catholic College at Maynooth in Ireland. Gladstone actually agreed with this, but thought Peel was being inconsistent.

In 1874, after his third period of office as Prime Minister, Gladstone published an essay in the *Contemporary Review* attacking the Roman Catholic Church, in particular, the rule that Catholics had to pledge allegiance to the Pope, whatever he might decree, (referring to Pius IX's proclamation on papal infallibility in 1870). Gladstone then issued his extremely widely-read pamphlet on papal infallibility *The Vatican Decrees*; among the replies was Newman's *Letter to the Duke of Norfolk* (no. 130).

This cartoon was published in the periodical *Vanity Fair* on 6 February 1869.

National Portrait Gallery (NPG 1978)

129

130

130 Henry Fitzalan-Howard, 15th Duke of Norfolk 1847–1917

Photograph, 39.4 × 34.2 (15½ × 13½)

Henry, 15th Duke of Norfolk, succeeded his father at the age of thirteen in 1860, the year in which he began attending Newman's Oratory School at Edgbaston. He completed his education by a Grand Tour of Europe, as Catholics were forbidden by their own hierarchy to attend Oxford or Cambridge, an obstacle the Duke deeply desired to overcome. In 1870, he became first President of the English Catholic Union, a body of Catholic laymen. He began to establish himself as the leader of the Catholic laity in England, and, gradually, as an intermediary between the British government and the Vatican. It was therefore entirely appropriate that in 1875 he should be the addressee of Newman's *Letter to the Duke of Norfolk* (no. 131), written in response to Gladstone's attack on the allegiance of British Catholics.

The Trustees of the London Oratory

131 John Henry Newman, 'A Letter Addressed to his Grace the Duke of Norfolk' London, 1875

(i) Autograph manuscript (ii) Book, 19 × 12.7 (7½ × 5)

In 1874 Gladstone published his pamphlet *The Vatican Decrees in their bearing on Civil Allegiance: A Political*

Expostulation, in which he raised the old argument that Catholics, who owed allegiance to a foreign power, the papacy, could not be loyal to England. The pamphlet was prompted by the decrees of the Vatican Council of 1870 (see no. 129). The pamphlet sold 150,000 copies and Newman decided that he must reply, as Gladstone had made particular reference to Catholic converts.

Newman thought his reply 'the toughest job I ever had', for he had to strike the right note to convince a popular audience and he felt too old for the task. He decided to write his reponse in the form of a letter to the 15th Duke of Norfolk (see no. 130), since he was the leading Catholic layman in England, and had been educated at the Oratory School. In his *Letter* Newman condemned those Catholics who 'having done their best to set the house on fire, leave to others the task of putting out the flame', and made clear his own loyalty to England as well as to the Pope. He argued in favour of papal infallibility while admitting that Popes of the past had made mistakes, particularly during the Renaissance; but he set limits on papal infallibility, emphasizing the importance of science and individual conscience: 'Certainly', he concluded, 'if I am obliged to bring religion into after-dinner toasts (which indeed does not seem quite the thing) I shall drink – to the Pope, if you please – still to conscience first, and to the Pope afterwards'.

The Fathers of the Birmingham Oratory

A LETTER

ADDRESSED TO HIS GRACE

THE DUKE OF NORFOLK

ON OCCASION OF

MR. GLADSTONE'S RECENT EXPOSTULATION

BY

JOHN HENRY NEWMAN D.D.

OF THE ORATORY

LONDON
B M PICKERING 196 PICCADILLY
1875

131

132 Sir John Emerich Edward Dalberg Acton, 1st Baron Acton 1834–1902

Franz von Lenbach

Green crayon and oil on panel, 64.8 × 52.1 (25½ × 20½)

PROVENANCE: Given by the artist to Marie Kalchreuth; bought from a German-born art dealer in Holland, c.1943, by Waldemar Croon junior; purchased from him through H. M. Cramer, 1958.

LITERATURE: National Portrait Gallery Report of the Trustees 1958–9 (1960), p. 10.

A Roman Catholic by birth, schooled at Oscott by Dr (later Cardinal) Wiseman (see no. 35), the historian Acton succeeded Newman in 1859 as editor of the monthly periodical *The Rambler*. Many of Acton's early historical writings were first published in this form.

Acton, unlike Newman, was a liberal, whose ideas had been moulded by six years study in Munich under the theologian Johan von Döllinger. Acton met with official Catholic disapproval of his writings more than once during the 1860s, and argued strongly against the definition of papal infallibility promulgated by the Vatican Council of 1870. Döllinger was excommunicated in 1871, together with other Catholic professors, for his resistance to the definition. Acton was a great friend of Gladstone (see no. 129) but tried to stop him from publishing his first pamphlet against the decrees, written after a visit to Döllinger. Acton and Döllinger corrected the proofs of Gladstone's second pamphlet, which prompted Newman's *Letter to the Duke of Norfolk* (no. 131). Acton expected excommunication himself, but it did not come. He found the arguments of Newman's *Letter* convincing, and the controversy died down. Acton devoted the rest of his life to historical writing, and in 1895 was made Regius Professor of Modern History at Cambridge.

The portrait is one of two similar half-lengths (the other is signed and dated 1879); it is unclear whether they were painted with a formal commission in mind.

National Portrait Gallery (NPG 4083)

133 Matthew Arnold 1822–88

Copyprint from a carte-de-visite photograph by Camille Silvy, 9 November 1861, in the National Portrait Gallery Archive

Matthew Arnold, the poet and critic and son of Thomas Arnold, (see no. 21), developed a great admiration for Newman, telling him in a letter of 1871 that Newman's influence and writings made an impression on him 'which is so profound and so mixed up with all that is most essential in what I do and say'. (Quoted by Ker, p. 666)

In 1880, when Newman was staying at Norfolk House in London, after being made Cardinal, he asked that Matthew Arnold should be invited to a reception for him. Arnold came because he 'wanted to have spoken once in my life to Newman'. (Ker, p. 726)

Matthew Arnold's younger brother Thomas, a Catholic convert, was employed by Newman at the Catholic University in Dublin and at the Oratory School, which he left in 1865; following this, for a time he renounced Catholicism.

134

134 Ambrose St John 1815–75

Unknown artist

Watercolour over a photographic base, 13.5 × 9.6 (5⅜ × 3¾)

Ambrose St John, who had studied oriental languages under Pusey at Christ Church, was curate to Henry Wilberforce (see no. 108). In 1843 he left to join Newman's community at Littlemore (see no. 78). He became a Roman Catholic in 1845, shortly before Newman, along with J. B. Dalgairns (see no. 87), and went with Newman to Rome where they were ordained as Catholic priests in 1847 and portrayed together by Maria Giberne (no. 81).

Ambrose St John was one of the founder members of Newman's Oratorian order, and his closest friend, replacing Hurrell Froude (see no. 57). He became headmaster of the Oratory School and the Oratory bursar, and supported Newman in all his activities. In 1875 he translated *True and False Infallibility* by the German Fessler, in order to help Newman in composing his *Letter to the Duke of Norfolk* (no. 131), and shortly afterwards suffered a breakdown and died on 24 May. Newman thought St John, an asthmatic, was suffering from overwork. 'His loss is the greatest affliction I have had in my life', Newman wrote. (Ker, p. 695) Newman was buried in St John's grave at Rednal (see no. 165).

The Fathers of the Birmingham Oratory

135 John Henry Newman

Jane Fortescue, Lady Coleridge

Black and white chalk on white paper, 57.2 × 41.5 (22½ × 16¼)

PROVENANCE: The Hon. Mrs Adams (Lady Coleridge's daughter); given to Miss M.E. Peacock; bequeathed to the Franciscan Sisters, 1959.

LITERATURE: Tristram.

Lady Coleridge (1825–78) was a frequent exhibitor of portraits at the Royal Academy between 1864 and her death in 1878. Her husband, created 1st Baron Coleridge of Ottery St Mary in 1874 and appointed Lord Chief Justice of England in 1880, was the son of one of the judges in the Achilli trial and befriended Newman after the trial; his brother became a Catholic priest.

On 25 May 1874 Lord Coleridge asked if Newman would sit for his wife so that she could finish from the life a head in crayon which she had begun from a photograph. (Letter quoted by Tristram) Newman agreed, and sittings took place during visits to the Coleridges in June and July 1874, in January 1875 and in June 1876. (Ibid.) Three portraits resulted, two of which were exhibited at the Royal Academy, in 1875 and 1877. In an undated letter to Newman (quoted by Tristram) Dean Church wrote: 'We were at Lady Coleridge's yesterday to see portrait No. 3, a full face. It is very successful and she thinks only wants a couple of hours' sitting to complete it. I am not sure that I do not like No. 2 best; but she has rather over-worked it, and made it too dark. No. 1 is placed 'on the line' [i.e. at eye-level, the most favoured position at the Royal Academy] in the Academy, but not quite as she wished it. The last, No. 3, promises to be, on the whole, the best.'

One portrait was sent to Newman in May 1877 and Newman wrote to thank the Coleridges for the 'wonderfully kind and beautiful present'; the only defect was the lack of signature. (Letter cited by Tristram) A mezzotint was made by Samuel Cousins in 1880 (no. 136) which shows a different portrait from no. 135; the date may indicate it was made from the portrait exhibited in 1877. The pose of no. 135 suggests that it may have been based on the photograph by Thrupp (no. 138) showing a very similar pose; it is likely that no. 135 was the first drawing, probably completed in 1874–5, and perhaps the portrait exhibited at the Royal Academy in 1875. Nothing is known of the remaining portrait.

The Franciscan Sisters of St Mary of the Angels

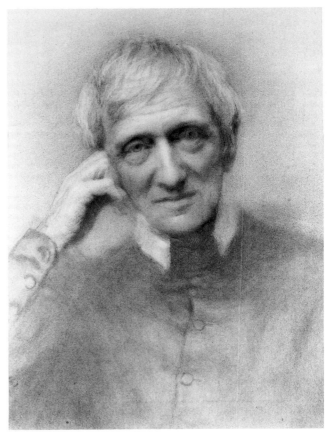

135

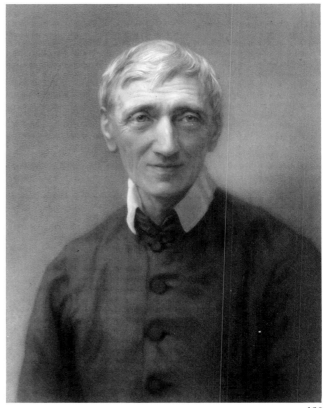

136

136 John Henry Newman

Samuel Cousins after Jane Fortescue, Lady Coleridge, 1880

Mezzotint, 33.4 × 25.5 (13⅛ × 10)

Engraved after one of Lady Coleridge's three drawings of Newman, probably that of 1877 (see no. 135). The portrait reproduced in the autobiography of Lady Coleridge's son appears to represent the drawing after which no. 136 was made, rather than the mezzotint itself (Stephen Coleridge, *Memories*, London, 1913, illus. f.p. 45). Coleridge commented on the engraving, 'the print was, I believe, the largest engraving of a head he [Cousins] ever achieved, and I think it was the last he completed before his death. I watched the creation throughout, first of the picture, and then of the engraving'. (Ibid., pp. 55–6)

National Portrait Gallery Archive

137 John Henry Newman

Robert White Thrupp

(i) Two carte-de-visite photographs, 10 × 6.1 (4 × 2⅜)
(ii) Carte-de-visite photograph, 10 × 6.1 (4 × 2⅜)

Robert White Thrupp had a studio at 66 New Street, Birmingham between 1867 and 1887, and Newman evidently sat for him several times.

The Fathers of the Birmingham Oratory

138 John Henry Newman

Robert White Thrupp

(i) Two carte-de-visite photographs, 10 × 6.1 (4 × 2⅜)
(ii) Two carte-de-visite photographs, 10 × 6.1 (4 × 2⅜)
(iii) Carte-de-visite photograph, 10 × 6.1 (4 × 2⅜)

The Fathers of the Birmingham Oratory

139 John Henry Newman

H. J. Whitlock

(i) Two carte-de-visite photographs, 10 × 6.1 (4 × 2⅜)
(ii) Three carte-de-visite photographs, 10 × 6.1 (4 × 2⅜)

Note the almost identical images in (ii); Newman wears the spectacles familiar from the early representations of him in only one of these.

Illustrated in colour on p. 34.

The Fathers of the Birmingham Oratory

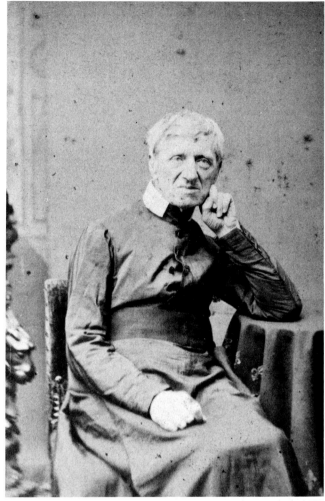

137

V Cardinal Newman 1879-90

Newman received his Cardinal's hat from Pope Leo XIII in Rome in 1879. He was extremely reluctant to accept the cardinalate, as hitherto cardinals who had no position in the hierarchy had had to settle in Rome, which Newman had no wish to do. This difficulty was overcome, however, and Newman was allowed to return to his Oratory at Birmingham, and to his small room crammed with pictures and objects which evoked memories from the whole of his long life: a photograph of the Church of St Mary the Virgin at Oxford (see no. 23), a portrait drawing of Henry Wilberforce (see no. 108), Richard Hurrell Froude's breviary (no. 57), a photograph of the young 15th Duke of Norfolk (see no. 130), and the watercolour of his titular church in Rome which he brought back from his journey to Rome (see no. 142).

Newman was inevitably much fêted, and more of the portraits for which he had always sat with extreme reluctance throughout his life were commissioned, notably Millais's dazzling portrait of him (no. 143), acquired by his great friend the Duke of Norfolk. Newman was always conscious of what seemed to him the increasing incongruity between his ageing and authoritative external appearance and his personality, which he felt remained youthful, even gauche. In these last years he grew increasingly aware that he was running a race with time, as he indeed observed to his young relative Emmeline Deane in 1887, when she wanted him to sit for an oil painting (no. 150). He wrote: 'What chance have I of doing my small work, however much I try? And you lightly ask me, my dear child, to give up the long days, which are in fact the only days I have'. Three more years remained to him; Newman died of pneumonia on the evening of 11 August 1890, at the age of eighty-nine.

140 Pope Leo XIII 1810-1903

Modern photograph from a glass negative by Emery Walker after a painting by an unknown artist

Pope Leo XIII, who made Newman Cardinal in 1879, was eager that the church should take account of developments in society, by upholding the rights of workers to form trade unions, and encouraging the objective study of history and science.

Newman travelled to Rome to have his first audience with Pope Leo XIII and be officially elevated to the College of Cardinals in April 1879. Newman presented him with the Roman edition of his four Latin Dissertations, and they conversed about the Oratory; Newman recorded that when he referred to the deaths of some of the Oratorians, the Pope 'put his hands on my head and said "Don't cry"'. Newman wrote of him: 'I certainly did not think his mouth large until

he smiled, and then the ends turned up, but not unpleasantly – he has a clear white complexion, his eyes somewhat bloodshot – but this might have been the accident of the day. He speaks very slowly and clearly and with an Italian manner'. (Ker, p. 720)

On 12 May Newman was informed that Pope Leo XIII had elevated him to the College of Cardinals, and on 15 May he was presented with his Cardinal's hat.

National Portrait Gallery Archive

141 Letter of Welcome to Newman from Stonyhurst College on his elevation to Cardinal 1879

Illuminated manuscript, 153.6 × 41.9 (60½ × 16½)

This is the most splendid example of a number of letters sent to Newman when he became Cardinal in 1879.

The Fathers of the Birmingham Oratory

142 San Giorgio in Velabro
L. Deane, signed and dated 1881

Watercolour on paper, 28.5 × 20.6 (11¼ × 8 1/16)

When Newman was made Cardinal in 1879 he took as his titular church in Rome San Giorgio in Velabro. This watercolour is probably the picture which Newman showed to Anne Pollen, the daughter of John Hungerford Pollen (see no. 105); she recorded in her diary that Newman said he had stayed in the house of a Protestant clergyman friend who had showed him a picture of the 'Rienzi Palace': 'I looked at it and said at once – "O that is St Giorgio in Velabrum", whereupon my friend said – "Then I must give it you" and

142

141

144

took it off his wall and I took it on with me to Birmingham'. (Quoted by Martin pp. 132–3).

The date of this watercolour however appears to preclude this being the watercolour of Newman's anecdote. It remains in his room today.

The Fathers of the Birmingham Oratory

143 John Henry Newman

Sir John Everett Millais, 1881

Oil on canvas, 62.2 × 52.2 (24$\frac{1}{2}$ × 20$\frac{9}{16}$)

PROVENANCE: The 15th Duke of Norfolk; by descent to the 16th Duke of Norfolk; acquired from the estate of the latter in 1981.

Newman first sat to Millais in the summer of 1881, while staying in London at Norfolk House. According to the *Life and Letters of Sir J. E. Millais* (ed. J. G. Millais, 1889, 2 vols, II, p. 386), when Newman came to sit to him, the artist pointed to the model's dais and said 'Oh, your eminence, on that eminence, if you please', and when Newman hesitated, urged him 'come, jump up, you dear old boy'. In a letter of 17 July, Newman wrote that Millais 'was very merciful in the length of time he exacted of me, and he is said to have been very successful'. (Tristram) There were seven sittings, each of one hour during which Lady Millais played the violin, which delighted Newman. (*Letters of Lord Blachford*, p. 407; Stephen Coleridge, *Reminiscences*, p. 155, both cited by Tristram)

Millais was delighted with the result: as Newman wrote to Maria Giberne on 21 July, 'Mr Millais thinks his portrait the best he has done and the one he wishes to go down to posterity by. Everyone who has seen it, is struck with it. He did it in a few short sittings'. (Tristram) Millais's fee was a thousand guineas. (Letters in Arundel Castle MSS) It appears that the Catholic Union had undertaken the commission with Agnew's who had it engraved by Thomas Barlow (see nos. 146, 147); the intention was for the venture to pay for itself and for the portrait then to be offered to the National Portrait Gallery. Owing to the failure of the edition (see no. 146), the portrait was bought by the Duke of Norfolk and came to the National Portrait Gallery only in 1981.

Illustrated in colour on p. 39.

National Portrait Gallery (NPG 5295)

144 Newman's Cardinal's robes, biretta, shoes and gloves

Newman's cardinal's robes have remained at the Birmingham Oratory. Unfortunately only the cape of the watered silk robes worn by Newman in the Millais portrait (no. 143) remains; the cassock is missing.

The Fathers of the Birmingham Oratory

145 Lace rochet

No rochets (the lace garment worn over a Catholic cardinal's cassock) belonging to Newman appear to have survived. No. 145, dating from the nineteenth century, is exhibited in order that Newman's cardinal's robes (no. 144) may be shown as worn in the portrait by Millais (no. 143).

The Trustees of the London Oratory

146 John Henry Newman

Thomas Barlow after Sir John Everett Millais, 1884

Mezzotint, 46 × 36.2 (18$\frac{1}{8}$ × 14$\frac{1}{4}$)

As was common practice in the nineteenth century, Millais's portrait of Newman was to be engraved, and the engravings sold through the firm of Agnew's, who often acquired the work of painters in order to make a profit out of selling engravings. In this case the Catholic Union entered into an agreement with Agnew's over the engraved edition of the portrait, with the publication date fixed for 1 May 1884, apparently with the object of buying the painting and presenting it to the National Portrait Gallery. (Letter of 24 February 1885 from James Knowles to W. S. Lilly, Arundel Castle MSS).

Unfortunately the edition was not the expected success; Agnew's therefore claimed the portrait, and the secretary of the Catholic Union, W. S. Lilly, was left to attempt to resolve the situation. Letters from Lilly to the 15th Duke of Norfolk in 1884 (Arundel Castle MSS) testify to the difficulties of

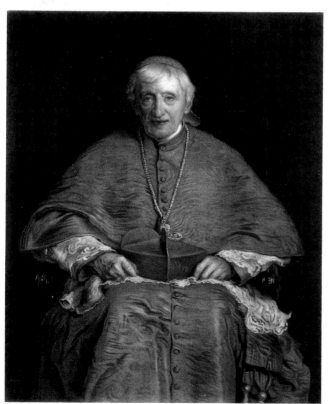

146

his position and express his regret of the failure of 'our speculation'. Lengthy discussions with Agnew's took place, and Lilly said he had even obtained Newman's agreement to sit for another portrait in order to try to call Agnew's bluff, but the sequence of events ended with the Duke of Norfolk agreeing to purchase the picture: 'It will ensure the picture being in good and fitting keeping; which is the next best thing if it does not come to the nation'. (Letter from John Knowles to W. S. Lilly, 21 February 1885, Arundel Castle MSS)

National Portrait Gallery Archive

147 Thomas Oldham Barlow 1824–98

Copyprint after a photograph by J. P. Mayall in the National Portrait Gallery Archive

Thomas Oldham Barlow, the engraver in mezzotint, was photographed as one of J. P. Mayall's series of artists in their studios. Millais' portrait of Newman (no. 143) is prominently displayed, along with examples of Barlow's work.

148 Henry Fitzalan-Howard, 15th Duke of Norfolk 1847–1917

Frederick Sargent

Pencil on paper, 25.7 × 17.8 (9 × 6$\frac{1}{2}$)
PROVENANCE: Purchased from Mrs G. Payne, 1983.

The Duke of Norfolk in his role as the leader of the Catholic laity in England (see no. 130) petitioned Pope Leo XIII through Cardinal Manning to make Newman a Cardinal; he also personally suggested this to the Pope.

National Portrait Gallery (NPG 5613)

149 John Henry Newman

Walter William Ouless, signed and dated 1880

Oil on canvas, 63.5 × 54.6 (25 × 21$\frac{1}{2}$)
PROVENANCE: Presented to Newman by his Birmingham parishioners, 1881.

LITERATURE: Tristram.

One of two versions of the portrait; the other hangs at Oriel College, Oxford (Lane Poole II, p. 200). The original proposal for the portrait came from the artist, who first had an approach made to Newman in 1877, without any result. The Regius Professor of Civil Law at Oxford, James Bryce, then took it up, with the idea of hanging the portrait in the Common Room at Oriel, and he was supported by Dean Church. A considerable amount of correspondence with Newman ensued, in which he refused to sit, saying, 'I don't like to be made an artistic subject', and that the proposal for his portrait to be hung at Oriel, about which he heard indirectly, was 'an anointing for the burial'. (Letters of 1 March and 23 January 1878, cited by Tristram) On receiving a direct request from Bryce on 15 March, however, Newman relented, and sittings took place in late 1878 and again in late 1879, after Newman had been made a Cardinal.

The Oriel portrait was exhibited at the Royal Academy in 1880. Newman's parishioners in Birmingham also wanted to present him with a portrait, to mark his eightieth year, and this second version of the portrait was painted, in which Newman also wears his scarlet zucchetto but different dress; it was presented to him on 19 June 1881. A copy was made for Trinity College, Oxford in 1889 by Mrs Bessie Percival.

The Fathers of the Birmingham Oratory

150 John Henry Newman

Emmeline Deane, 1889

Oil on canvas, 111.8 × 89.5 (44 × 35¼)

PROVENANCE: Purchased by Newman for his doctor, George Vernon Blunt, by whom given, 1896.

LITERATURE: Tristram; Ormond I, pp. 338–9.

Emmeline Deane's mother, Mrs Louisa Deane, was the daughter of Sealy Fourdrinier, the brother of Newman's mother Jemima (see no. 1), and Newman had known her from childhood. Emmeline Deane, a keen artist, persuaded her mother to ask Newman for a sitting in 1884; he replied doubtfully on 7 May, arguing, 'they say that no one ever succeeded in taking me, which makes it unkind to let anyone try'. (Tristram) A charcoal drawing and an autotype were the result, but in 1887 Emmeline Deane asked Newman to sit for an oil painting; once more, he was reluctant to spare the time, comparing himself to St Bede and St Anselm running a race with time: 'What chance have I of doing my small work, however much I try? And you lightly ask me, my dear child, to give up the long days, which are in fact the only days I have!'. (Letter of 3 March 1887, copy in National Portrait Gallery Archive)

Six months later he sat for a second portrait, a charcoal sketch, followed by an oil painting, with sittings in September 1887 and March 1888. Newman found the sittings onerous, and the artist subsequently repainted all of the portrait except the face. She continued to work on it in 1889, when she painted the present portrait, in a different costume, with sittings from Newman in April, June and July. In 1890, she repainted the background, as she found it

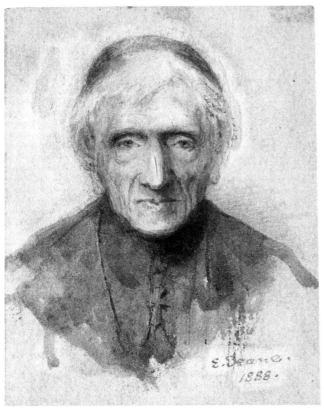

151

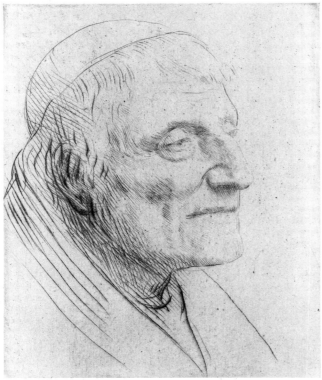

152

'cold and chalky' and was paid 100 guineas by Newman. (Memorandum by E. Deane in National Portrait Gallery Archive; Ormond) A small pencil and watercolour study may be related to it (no. 151)

National Portrait Gallery (NPG 1022)

151 John Henry Newman

Emmeline Deane, signed and dated 1888

Watercolour and pencil on paper, 9.3 × 7.1 ($3\frac{5}{8}$ × $2\frac{3}{4}$)

Emmeline Deane took several portraits of Newman (see no. 150). The pose of the sketch appears to relate quite closely to the National Portrait Gallery picture (no. 150) which she began in either late 1888 or 1889 and had sittings for in 1889. The direction of the eyes is however quite different, and it is possible the sketch dates from 1887–9, the period of her first oil portrait.

The Fathers of the Birmingham Oratory

152 John Henry Newman

Photograph after an etching by Alphonse Legros

The French artist and sculptor Alphonse Legros was working in England in the 1870s and 1880s and teaching at the Slade School of Art (see no. 153). During this period he produced a number of portrait etchings including the two English Cardinals Manning and Newman. According to the catalogue of Legros's graphic works (*A Catalogue of the Etchings, Drypoints and Lithographs by Professor Alphonse Legros in the collection of Frank E. Bliss*, London, 1923) only four impressions were ever made of which three were of the second state. It is not known if Legros had a sitting, but it is interesting to note that his pupil at the Slade School, Elinor Hallé, also chose Newman as the subject of her medal in 1881 (no. 154).

153 John Henry Newman

Elinor Hallé, signed and dated April 1885

Coloured chalks on grey paper, 29.5 × 25.7 ($11\frac{5}{8}$ × $10\frac{1}{8}$)

PROVENANCE: Acquired by the Royal Library by the Librarian J. W. Fortescue.

LITERATURE: Philip Attwood, 'The Slade Girls', *The British Numismatic Journal*, vol. 56, 1986, pp. 148–177; Philip Attwood, 'Elinor Hallé', *The Medal*, no. 6, Spring 1985, pp. 16–22 (ill. p. 18).

Elinor Hallé, the daughter of the conductor Sir Charles Hallé, studied at the Slade School of Art, under the French sculptor Alphonse Legros, who inspired her (and a number of her contemporaries (see no. 155) to undertake the design of medals. In 1885 she won first prize in a competition held by the newly-formed Society of Medallists with a medal of Cardinal Newman (no. 154), for which no. 153 is a drawing. No. 153 was exhibited at the Royal Academy in 1886 in its own right; the medal was exhibited there in the following year.

Elinor Hallé was strongly influenced by the great early

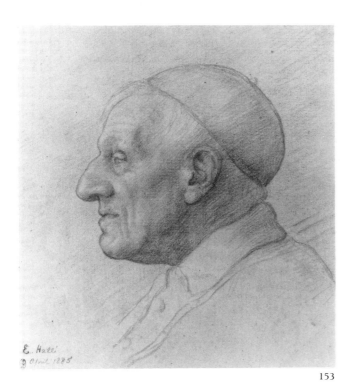

153

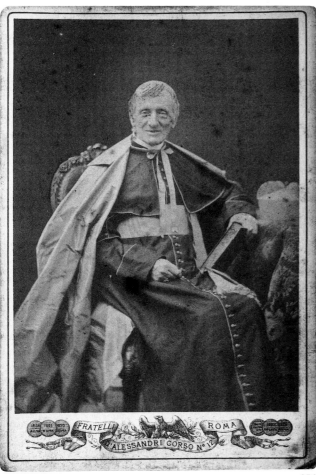

156

Renaissance medallist, Pisanello, in her choice of the profile pose, and indeed in the design of the whole medal. Her contemporary Feodora Gleichen wrote in 1901 in a letter to M. H. Spielman (quoted by Attwood): 'Miss Hallé's medal of Cardinal Newman is I believe considered by French connoisseurs and the authorities on medals at the British Museum to be the finest work of the kind since Pisanello'. She was brought up a Catholic, which presumably influenced her choice of sitter, but no evidence has emerged on the question of whether Newman gave her a sitting for this drawing; it seems likely from the appearance of the drawing that he did.

Lent by Her Majesty The Queen (Windsor 13653)

154 John Henry Newman

Photograph of a medal by Elinor Hallé in the collection of the Musée d'Orsay, Paris

See no. 153.

155 John Henry Newman
Lilian Swainson, *c*.1885

Bronze medal

LITERATURE: Philip Attwood, 'The Slade Girls', *The British Numismatic Journal*, vol. 56, 1986, pp. 148–177, ill. p. 175, pl. 172.

Lilian Swainson (born 1865) studied at the Slade School of Art between 1880 and 1886, where, like her contemporary Elinor Hallé (see no. 153), she was taught by Alphonse Legros and produced a number of medals. Her medal of Newman was exhibited at the Society of Medallists in 1885; a much less convincing likeness as well as a less elegant design than Elinor Hallé's medal, it was placed in the third class. The source of the likeness used is unknown. On the reverse of the medal is a cross.

The Trustees of the British Museum, Department of Coins and Medals (BM 1924–4–18–4)

156 (i) John Henry Newman
Fratelli Alessandri, Rome, 1879

Cabinet photograph, 16.2 × 10.7 ($6\frac{3}{8}$ × $4\frac{3}{16}$)

An official portrait of Newman as Cardinal, taken in Rome.

The Fathers of the Birmingham Oratory

(ii) John Henry Newman and others

Copy photograph from a negative by an unknown photographer at the Birmingham Oratory (1879)

A group portrait of Newman, taken at Rome. His fellow Oratorian, William Neville, who accompanied him to Italy, stands behind him.

157 John Henry Newman

Herbert Rose Barraud, *c.*1888

Carbon print, 24.5 × 17.9 (9⅝ × 7)

Taken for Barraud's first series of volumes of photographs of notable sitters, *Men and Women of the Day*, and published in 1888. Newman disliked the emphasis on his slightly threadbare coat, saying it made him appear to advertise his poverty. (Martin, p. 139)

Illustrated as frontispiece on page 2.

National Portrait Gallery Archive

158 John Henry Newman and Oratorians

Copy photograph from a negative at the Birmingham Oratory

Newman with his fellow Oratorians at Birmingham, taken in the Oratory cloister.

159 (i) John Henry Newman

Unknown photographer, 1890

Two cabinet photographs, 16.5 × 10.8 (6½ × 4¼)

Photographs of Newman taken in May 1890, three months before his death. He wears the watered silk robes of the Millais portrait (no. 143).

(ii) John Henry Newman

Unknown photographer

Cabinet photograph, 16.5 × 10.8 (6½ × 4¼)

An image of Newman towards the end of his life, perhaps contemporaneous with no. 160.

The Fathers of the Birmingham Oratory

160 John Henry Newman in his room at Birmingham Oratory

Two copy photographs from negatives by Peter Moss at the Birmingham Oratory

These photographs show Newman working in his room towards the end of his life; even in 1887 he was at work on a third edition of his select *Treatises of St Athanasius*. Newman's room at the Oratory remains exactly as he left it, a small room divided into book-lined study and chapel, hung with small portraits of people close to him.

The photographs were taken by a fellow Oratorian.

161 Newman's viola

Newman was an accomplished musician throughout his life; from early days at Oxford (see no. 16) where he played Beethoven quartets with Joseph Blanco White (see no. 20), to his days at the Birmingham Oratory, music was important to him. When in 1865 he was offered the gift of a violin by Frederic Rogers (see no. 121) and R. W. Church, he wrote: 'I only fear that I may give time to it more than I ought to spare. I could find solace in music from week to week's end . . . I never wrote more than when I played the fiddle. I always sleep better after music. There must be some electric current passing from the strings through the fingers into the brain and down the spinal marrow. Perhaps thought is music'. (Ker, pp. 573–4)

The Fathers of the Birmingham Oratory

162 Newman's music stand

130.8 × 68.5 × 66 (51½ × 27 × 26)

Newman's music stand was converted into a lectern and remains in Newman's library at Birmingham Oratory.

The Fathers of the Birmingham Oratory

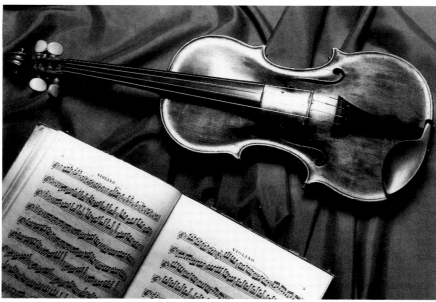

161

Presented to His Eminence Cardinal Newman by his grateful humble servant the Composer, Joseph Short, 1880.

Inscribed to
HIS EMINENCE CARDINAL NEWMAN.

MARCHE CARDINALE

† BY †

Joseph Short.

Ent. Sta. Hall. Price 3/-

Birmingham.
J. SHORT, 220, GT LISTER STREET.

Mass St Joseph for 4 Voices & Organ. Price 3/6 nett.
'Deus Israel' Quartett & Chorus. Price 1/6 nett.
Salve Regina for 4 Voices. Price 1/ nett.

163

163 'Marche Cardinale'

Book, 34.6 × 26.7 (13⅝ × 10½)

Bound with a collection of music relating to Newman, including several settings of 'Lead Kindly Light', by George MacFarren, the *Marche Cardinale* was composed by Joseph Short on Newman's elevation to the cardinalate, and presented to him in 1880, as the inscription records.

The Fathers of the Birmingham Oratory

164 Newman's funeral: front page of 'The Daily Graphic' 20 August 1890

Photograph of original newspaper in the National Portrait Gallery Archive

Newman died from pneumonia on 11 August 1890. His funeral took place on 19 August, at the Oratory Church, and was attended by all the leading English Catholics including the Duke of Norfolk, as well as the President of Trinity College, Oxford, where Newman had been an undergraduate, and the Provost of Oriel, where he had been a Fellow. According to the description in *The Graphic*: 'The pilasters [of the church] and the wall beneath the clerestory were draped in black, edged with yellow. The sanctuary was hung with black, and the stalls and pulpit were also draped. Four tall tapers guarded the coffin, which was before the

altar, and the level light of the six candles on the altar brought out the pale crucifix against the sombre hangings'.

Newman's body was taken to the Oratory house at Rednal for burial: *The Graphic* shows crowds thronging outside the Oratory as the funeral procession passes.

165 Newman's grave at Rednal

Copyprint after a photograph at the Birmingham Oratory

Newman gave William Neville instructions in the event of his death in 1876: 'I wish, with all my heart, to be buried in Father Ambrose St John's grave'.

On his memorial tablet was the Latin inscription chosen by him: 'Ex umbris et imaginibus in veritatem' ('from shadows and images to truth').

166 Newman's memorial tablet, Birmingham Oratory

Copyprint after an original photograph at the Birmingham Oratory

A memorial tablet to Newman was placed in the red-brick Oratory cloisters, designed by Henry Clutton, along with that commemorating Ambrose St John and every other Oratorian; its position has subsequently changed, owing to the rebuilding of the Church.

167 Drawing for a memorial to John Henry Newman

Francis Derwent Wood

Copy photograph after a drawing in the Victoria and Albert Museum [E938.1945]

The original, undated, drawing, in pencil and black ink on squared paper, is unidentified, but is a memorial to a Cardinal with a plaque incorporating a profile similar to Newman's and is highly likely to represent a design for a memorial to Newman. The memorial is topped with a figure of the Virgin and Christ and incorporates the inscription LUX MUNDI. The drawing probably dates from the 1920s.

168 John Henry Newman

W. S. Moore, signed and dated 1890

Terracotta bust, stamped J. Loughton, Hardleywood, Birmingham, height 34.3 (13½)

A bust produced by the Birmingham firm of J. Loughton in commemoration of Newman's death. At least one other bust from the edition is known (see Iconography).

The Duke of Norfolk

170

169 John Henry Newman

Photograph of the monument to Newman by Léon Joseph Chavalliaud outside the London Oratory

LITERATURE: M. Napier & A. Laing (eds.), *The London Oratory Centenary 1884–94*, pp. 63–4.

The French portrait sculptor Léon Joseph Chavalliaud (1858–1919) was working in London between 1893 and 1904, when he was commissioned to sculpt the full-length figure of Newman on the monument to him erected in 1896. The memorial with its shell-headed niche for the figures was designed by Bodley and Garner and the carved stone tabernacle itself made by Farmer and Brindley.

The 15th Duke of Norfolk, who had contributed substantially to the cost of the London Oratory Church (designed by Herbert Gribble) was chairman of the memorial committee responsible for this monument.

170 The Birmingham Oratory Church of the Immaculate Conception

(i) exterior under construction

(ii) interior

Copyprints after original photographs at the Birmingham Oratory

The church, a domed basilica, was built between 1903 and 1909 as a memorial to Newman and was designed by E. Doran Webb. The interior, dominated by aisles of Corinthian columns, is lavishly decorated in coloured marbles. It includes an altar (the Sacred Heart altar) designed by John Hungerford Pollen, which stood originally in the old church (see no. 92).

169

171 John Henry Newman, 'The Dream of Gerontius' 1865

(i) Draft: manuscript, 29.2 × 39.4 (11½ × 15½)
(ii) Fair copy: manuscript, 34.3 × 43.8 (13½ × 17¼)

On 17 January 1865, Newman found that it 'came into my head' to write his famous poem, 'I really cannot tell how, and I wrote on till it was finished, on small bits of paper'. (Quoted by Ker, p. 574) The poem was published in two parts in the periodical *The Month*, in May and June. It was a tremendous success, as a result of which Newman's poetry was published in a collected edition.

The Dream of Gerontius, a vivid, intense verse dialogue of the passage of the soul of Gerontius from his body to purgatory includes the well-known verses 'Praise to the Holiest in the Height', and is Newman's outstanding achievement as a poet.

Illustrated in colour on p. 37.

The Fathers of the Birmingham Oratory

172 'The Dream of Gerontius' 20th edition, 1885

Book, 12.3 × 8.5 (4⁶⁄₁₀ × 3³⁄₈)

This copy of the 20th edition of Newman's poem, first published in 1865 (see no. 171), is inscribed on the flyleaf: 'With Cardinal Newman's/Kindest and best wishes/Dec 18. 1885'.

David Mozley Esq.

173 Sir Edward Elgar, Bt. 1857–1934

Copy photograph by Dr Grindrod

Elgar wrote the oratorio *The Dream of Gerontius*, generally regarded as his masterpiece, while living at Hereford. He finished his orchestration on 3 August 1900 (the vocal score was ready in July) and the work was given its first performance at the Birmingham Festival on 3 October, conducted by Hans Richter, who had also conducted the first performance of Elgar's *Enigma Variations* in 1899. The oratorio was not at first well received, in part because of the Catholic theology animating the poem: it was said that it 'stinks of incense'. Subsequent performances reversed this judgement however, particularly the very successful German performances in 1901 and 1902.

National Portrait Gallery Archive

174 Part of Sir Edward Elgar's manuscript of the score of 'The Dream of Gerontius'

Copy photograph of the original score at the Birmingham Oratory

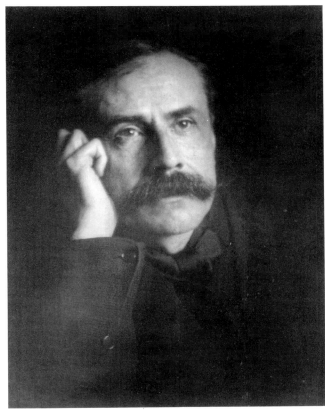

173

175 Two programmes for the first performance of Elgar's 'Dream of Gerontius' 1900

(i) Copy signed by Elgar and others
(ii) Unsigned copy

No. 175(i) has been autographed on the flyleaf by Elgar, the conductor Hans Richter, and the soloists Edward Lloyd (Gerontius) Harry Plunkett-Greene (Priest) and Marie Brema (Angel) as well as by others involved in the Birmingham Festival, notably Miss (later Dame) Clara Butt and the composers Samuel Coleridge Taylor and Hubert Parry.

The first performance of Elgar's 'Sacred Cantata' was given on the morning of Wednesday 3 October 1900.

Royal College of Music

Iconography

Note: This is an amended, updated version of the iconography published in Ormond, *Early Victorian Portraits*, I, pp. 339–341.

References are to exhibit numbers.

1815
Caricature drawing by unknown artist: *The Spy Society* (Birmingham Oratory; no. 10).

1829
Drawing by Maria Giberne of Newman with his family, repr. *Art Journal* (1890), p. 316 (location unknown; see no. 13).

1832
Drawing by Maria Giberne, with T. Mozley and R. H. Froude (location unknown; old photograph at Oriel College, Oxford).

1841
Caricature drawing by J. R. Green (Truro Cathedral). Anonymously etched (NPG Archive; no. 56). Related woodcut published *Illustrated London News*, V (1844), 45. Similar undated watercolour (Magdalen College, Oxford; see no. 54).

*c.*1841
Marble bust by Richard Westmacott (Birmingham Oratory; no. 72). Engraved J. Bridges (example in NPG Archive).

1844
Drawing by George Richmond (Oriel College, Oxford), listed in Richmond's 'Account Book' (photostat copy, NPG Archive, p. 37, under 1844). Exhibited *Victorian Exhibition*, New Gallery, London, 1891–2 (384). Anonymously engraved with variant collar, published T. Maclean, 1856 (example in British Museum). Study (NPG 1065; no. 68).

*c.*1845
Miniature by Sir William Charles Ross (Birmingham Oratory; no. 71). Watercolour study dated 1845 (Keble College, Oxford; no. 70).

*c.*1846
Painting by Maria Giberne: *Newman and Ambrose St John at Rome* (Birmingham Oratory, no. 81).

*c.*1846–7
Painting by Maria Giberne (Birmingham Oratory; no. 83).

1850
Lithograph by J. A. Vinter, after a drawing by Maria Giberne, published Lander, Powell & Co,

Birmingham, 1850 (example in NPG Archive; no. 85).

1850
Anonymous caricature engraving, *A Sketch from the Oratory* (example in NPG Archive; no. 89).

*c.*1851
Painting by Maria Giberne: *Newman Lecturing at the Corn Exchange* (Birmingham Oratory; no. 100).

1852
Painting by James Doyle, *The First Provincial Council of Westminster July 1852*, group portrait includes Newman (Oscott College).

1866
Marble bust by Thomas Woolner. Exhibited Royal Academy, 1867 (Keble College, Oxford; no. 116). Plaster casts (Trinity College, Cambridge and NPG 1668).

*c.*1874
Painting by W. T. Roden (Keble College, Oxford; no. 128). Replica by Roden of 1879 in the City Museum and Art Gallery, Birmingham; another version in Manchester City Art Gallery.

1874–5
Two drawings by Lady Coleridge, one exhibited Royal Academy, 1875 (1069) (The Franciscan Sisters of St Mary of the Angels; no. 135).

1875
Painting by G. Molinari (Collection of A. Slade, 1939).

1877
Lithograph by 'Spy' (Sir Leslie Ward), published *Vanity Fair*, 20 January 1877 (example in NPG); original water-colour (Birmingham Oratory; no. 127).

*c.*1877
Drawing by Lady Coleridge. Exhibited Royal Academy, 1877 (1266). Either this or the drawing of *c.*1875 engraved by S. Cousins, published Colnaghi, 1880 (example in NPG Archive; no. 136).

1879
Lithograph by 'AS', published *The Whitehall Review*, 10 May 1879.

1880
Painting by W. W. Ouless (Oriel College,

Oxford). Exhibited Royal Academy, 1880 (438). Repainted in 1881. Etched by P. Rajon (example in NPG). Another version by Ouless, (Birmingham Oratory; no. 149). Copy by Mrs B. Johnson (Trinity College, Oxford)

1881

Painting by Sir J. E. Millais (NPG 5295; no. 143). Engraved by T. O. Barlow, published Agnew, 1884 (example in NPG Archive; no. 146). Engraving exhibited Royal Academy, 1884 (1408). Copy by A. de Brie (Keble College, Oxford).

1881

Terracotta bust by M. Raggi. Exhibited Royal Academy, 1881 (1483).

*c.*1881

Painting by E. Jennings, after a photograph of 1879 (Magdalen College, Oxford).

*c.*1883

Marble bust by F. Verheyden. Exhibited Royal Academy, 1883 (1526).

1884

Drawing by Emmeline Deane (English College, Rome). See NPG 1022 below.

1885

Drawing by Elinor Hallé (Royal Collection, Windsor; no. 153). Exhibited Royal Academy, 1886 (1505). Preparatory study for a bronze medal by the same artist was exhibited Royal Academy, 1887 (1921). Example in Musée d'Orsay, Paris; see no. 154. Bronze medal by Lilian Swainson (British Museum; no. 155).

*c.*1885

Etching by H. R. Robertson. Exhibited Royal Academy, 1885 (1597).

1887

Drawing by Emmeline Deane (formerly collection of the artist).

1887–9

Painting by Emmeline Deane (The Oratory School, Woodcote, Reading). Watercolour sketch by Emmeline Deane (no. 151).

1889

Painting by Emmeline Deane (NPG 1022; no. 150).

Posthumous

1890

Terracotta bust by W. S. Moore (collection of the Duke of Norfolk; no. 168). Another example, collection of Stephen Wildman.

1892

Bust by Sir T. Farrell (University Chapel, Dublin). Exhibited *Royal Hibernian Academy*, 1892.

1892

Statuette by W. Tyler. Exhibited Royal Academy, 1892 (1931).

1896

Marble statue by L. J. Chavalliaud (London Oratory; see no. 169). Reproduced *Magazine of Art* (1896), p. 463.

1912

Statue by H. Pegram (Oriel College, Oxford). Model exhibited Royal Academy 1912 (1782).

1915

Bronze bust by A. Broadbent (part of a memorial) (Trinity College, Oxford). Exhibited Royal Academy, 1915 (1848).

1926

Pencil drawing by Powys Evans (copy) (Powys Evans Sketchbooks Box 9, p. 47, NPG Archive).

Undated

Painting by D. Woodlock, possibly after a photograph by Barraud; no. 157 (collection of E. F. Mahoney, 1912). Exhibited *Franco-British Exhibition*, 1908.

Painting by A. R. Venables (collection of the Earl of Denbigh, Newnham Paddox, 1907; bequeathed to Birmingham Oratory by Ethel Maude Watts, on loan to Catholic Chaplaincy, University of Birmingham). Exhibited *Brighton Loan Exhibition*, 1884 (267). Repr. A. D. Culler, *The Imperial Intellect* (1955), frontispiece.

Design for a Monument by F. Derwent Wood, probably 1920s (Victoria and Albert Museum; no. 167).

Drawing by R. Doyle (British Museum, no. 107).

Drawing by H. Doyle and drawing by R. Doyle, both repr. A. D. Culler, *The Imperial Intellect* (1955), f.p. 140, as collection of Birmingham Oratory.

Terracotta bust by unnamed artist (collection of Miss Draper, 1937 [possibly one of those by W. S. Moore, 1890 or M. Raggi, *c.*1881 listed]).

Engraving by J. Brown. Reproduced *Bookman*, XXVI (1904), 50.

Etching by A. Legros (see no. 152).

Painting by Rebecca Dulcibella Dering, (Baddesley Clinton, National Trust). Repr. Guidebook (1980) p. 31.

Drawing by unnamed artist, sold Christie's South Kensington, 29 November 1982 (250).

Painting (oval) by unnamed artist after a photograph by Maclean and Haes (on loan to The College, Littlemore; see no. 113).

Photographs

See nos. 111–13, 115, 137–9, 156–60.

Index of exhibits

List of Lenders

All references are to exhibit numbers

Her Majesty The Queen 153

The Archbishop of Westminster 25

The Visitors of the Ashmolean Museum, Oxford 18

Birmingham Museums and Art Gallery 94

The Fathers of the Birmingham Oratory 7, 9, 10, 16, 24,
 26, 50, 52, 53, 57, 58, 60, 62, 63, 71, 72, 73, 79, 80, 81,
 83, 84, 88, 90, 91, 92, 95, 100, 104, 105, 106, 111, 112,
 113, 120, 122, 127, 131, 134, 137, 138, 139, 141, 142,
 144, 149, 151, 156, 158, 159, 160, 161, 162, 163, 165,
 166, 170, 171, 174

The British Library Board 49, 74

The Trustees of the British Museum 107, 155

The Governing Body, Christ Church, Oxford 59

Mr Philip Anthony Fourdrinier Fenn 1, 115

The Franciscan Sisters of St Mary of the Angels 135

The Warden and Fellows of Keble College, Oxford
 48, 69, 70, 116, 128

The Trustees of the London Oratory 82, 86, 87, 101,
 102, 103, 130, 145, 169

The Misses M. & E. Miller 11, 13

David Mozley Esq. 2, 3, 4, 5, 8, 12, 14, 22, 172

National Portrait Gallery, London 15, 19, 20, 21, 27, 28,
 29, 30, 31, 32, 33, 34, 35, 36, 37, 38, 40, 41, 46, 51,
 55, 56, 61, 64, 65, 67, 68, 85, 89, 93, 96, 97, 98, 99, 108,
 109, 110, 114, 117, 118, 119, 121, 123, 124, 125, 126,
 129, 132, 133, 136, 140, 143, 146, 147, 148, 150, 152,
 157, 164, 173

The Duke of Norfolk 168

The Royal College of Music 175

The Society of Antiquaries of London 45

Jane and Clive Wainwright 42, 43, 44, 47, 66